IMAGES
of America

UPPER ARLINGTON

On the cover: **UPPER ARLINGON PARADE.** Upper Arlington children, riding their bicycles, join in Upper Arlington's famed Fourth of July parade—a tradition that still endures. (Courtesy of Linda Snashall Cummins.)

IMAGES
of America

UPPER ARLINGTON

Stuart J. Koblentz and Kate Erstein
on behalf of the
Upper Arlington Historical Society

ARCADIA
PUBLISHING

Published by Arcadia Publishing
Charleston, South Carolina

Printed in the United States of America

Library of Congress Catalog Card Number: 2007943799

For all general information contact Arcadia Publishing at:
Telephone 843-853-2070
Fax 843-853-0044
E-mail sales@arcadiapublishing.com
For customer service and orders:
Toll-Free 1-888-313-2665

Visit us on the Internet at www.arcadiapublishing.com

For E Haley and Don Merchant

CONTENTS

ACKNOWLEDGMENTS

Works such as these are never possible without the support of people who have an interest in preserving history and a passion for sharing what they know. As you read the names of the people listed on this page, please in keep mind that they are listed here for contributing their time and effort to make this book possible. Melissa Basilone and the people at Arcadia Publishing have gone above and beyond our expectations in supporting this project with technical expertise, not to mention their patience while we searched for just the right cover image. We thank the Upper Arlington Historical Society for their support of the project and access to its archives. The Upper Arlington Public Library and the Upper Arlington Senior Center helped us find space at their facilities for our scanning dates. The City of Upper Arlington, the Upper Arlington Police, Fire, and Parks and Recreation departments provided photographs and assistance. Erin Bannon, Jana Bradford, Bob Harper, and Judy Tackett assisted during public scanning dates with record keeping and documentation. Community members who opened their personal collections as well as provided valuable leads to us, include Richard Barrett, Mary Koblentz-Bowen, David and Elaine Buck, Lisa Zipfel Bueche, Thomas A. Burke, Jackie Cherry, Linda Snashall Cummins, the Dawson family, Virginia Hetrick Dill, the Galbreath family, Carlyle Handley, Bob Harper, Julia Forsythe Harrison, David A. Hartmann, Willis Hodges and family, Susan Knell, Ann Armstrong Knodt, Jean S. Lombard, Robin Lorms, Lenore and David Mastracci, Tom Matheny, Priscilla Mead, Esther Miller, Scott Miller, Carol Ellies Moorehead, Sue Nemer, Jim Newlon, Fred Phening, Dusky Reider, Nancy Rundels, Dr. Martin P. Sayers and Marjorie Garvin Sayers, the Schoedinger family, Robert W. Wagner, Jean Parks Williams, Judy Williams, and A. W. Wilson. We also recognize the Upper Arlington Education Foundation, the Ohio Historical Society, and St. Agatha Parish for their help and access to their collections. The Ohio State University Cartoon Research Library and archives donated materials. E Haley provided invaluable help with scanning, copy verification, layout assistance, and moral support. Last but not least, we also thank our families for their support and understanding during this project.

INTRODUCTION

People are curious about the past of Upper Arlington and often wonder how the community was named. How can there be an "upper" Arlington if there is no "lower" or even plain "Arlington" in the area?

When brothers King and Ben Thompson were creating their development, they called it the Country Club District, and modeled it after a development of the same name in Kansas City, Missouri. At the time, what is now the village of Marble Cliff was called Arlington. The fact that the new community was north, "upper" was appropriate, and in 1916, Upper Arlington was so named. However, there was (and still is) another Arlington in Hancock County south of the city of Findlay. To end the confusion, the post office insisted that the community in Franklin County change its name and residents chose Marble Cliff.

That puzzle solved, it should be mentioned that Upper Arlington is fortunate to have had its history well documented and written about in the authoritative and expansive 1976 work called the *History of Upper Arlington* by the History Committee of the Upper Arlington Bicentennial Committee that was updated in 1988. In the years since that text book was completed, much has changed within the community, as well as within the book industry. Photographic reproduction and digital imaging are chief among those improvements.

The book that you now hold in your hands, from its initial conception, was meant to augment the 1988 book, provide a broader look at the early days of the Thompson's development south of Lane Avenue, and provide a glimpse into the intermediate past of the period of 1945 to 1980. The authors also hope that this work will spark the realization—especially in the baby boom–generation readers—that while 1980 may seem like yesterday, it was 28 years ago from 2008. If you protest and say that this time period is not historical, ask yourself if not now, when will it become history?

Assembling this book has taught us a great deal about how much of the community history is documented in original photographs that are easy to access and how much is not. While the *Norwester* magazines of the early years of the community are rich in low-resolution images, the fate of the higher quality original images is unknown and thus inaccessible. This project has also demonstrated how difficult it is to find high quality original photographic prints of Upper Arlington's pre-World War II era. We heard from many residents who were certain that local photography studios, businesses, and newspapers "had to have images of interest in their archives." Following those leads led to the discovery that these archives no longer exist, that archives were never kept beyond a year or so, or that they had been unceremoniously thrown out when the business closed or when film gave way to digital imaging.

The direction of the book has needed to go where the images have taken us. Thus this is not an all-encompassing book. As much as we wanted to bring images of long-lost landmarks, such as the two-story Lane Avenue G. C. Murphy's store and the movie theater in the same shopping center, images of these places do not exist to our knowledge. Space constraints also prevent the coverage of the rich history of the communities of faith in Upper Arlington.

The heroes and heroines of this work are your neighbors, family members, organizations, and the City of Upper Arlington that opened up their personal and institutional collections for the purpose of helping document the history of the city. Public scanning sessions were held at the Upper Arlington Public Library and also Upper Arlington Senior Center in Fall 2007 so that the volunteers working on the book could meet with community members. In almost every case, when a community contributor brought an image forward saying that we "wouldn't be interested in this," the image has sparked excitement in us and we are sure it will in you as well.

The challenge is passed to all who have called Upper Arlington home. Share your original pictures with the Upper Arlington Historical Society and the community to help build a stronger and larger collection of historical images for the generations to come.

One

SOUTHERN PERRY TOWNSHIP

The land that brothers King and Ben Thompson purchased from James T. Miller to develop into Upper Arlington was originally part of Franklin County's Perry Township. Perry Township was erected in 1820 from a portion of Washington Township and a portion of Norwich Township. In 1900, Perry Township was 10 miles long from its southern-most point to its northern-most point and varied anywhere from one to three miles in width from east to west.

The lack of a post office was cited by the 1905 *Centennial History of Columbus and Franklin County* as the main reason why early Perry Township failed to develop a town center of its own. Most pioneers relied on the post offices at Dublin, Worthington, and Columbus for mail service. The place most similar to a town that Perry Township could boast in the mid-19th century was Shattucksburg, named for Simon Shattuck, who tried to sell lots to early residents. Even without a village of its own, the township government operated a network of one-room schoolhouses, with one placed approximately every two to three miles through the township. Teachers boarded with local families and most students attended school from the end of the harvest until spring planting. Following the end of World War I, the one-room schools were consolidated into two centralized buildings, one on Fishinger Road and the other on Dublin Granville Road, and the school year was lengthened.

Following the establishment of Upper Arlington in 1913, a series of land annexations northward increased the city footprint at the expense of southern Perry Township. Farming, as a family run business, continued until the late 1970s. One of the last family operated farms was run by James and Anna Marie Davidson Drake, a direct descendent of James McCoy and Zipporah Richards McCoy. The oldest home in modern Upper Arlington was built in 1835 by John and Nancy Criswell Kenny east of Kenny Road. The house also holds the distinction of the longest continuous family ownership and is still owned and occupied by direct descendents of its builders.

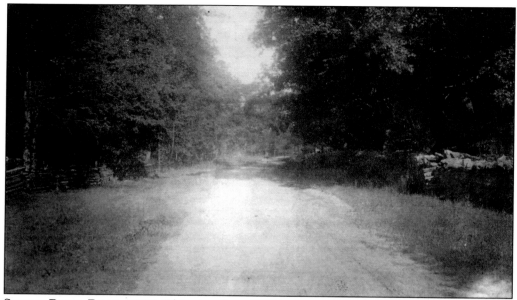

SCIOTO RIVER ROAD, 1895. This view from 1895 looks northward along the old Scioto River Road, which had its roots in the Scioto Trail that was followed by Native Americans along the Scioto River. The stone wall along the right marked the property of James T. Miller and is now occupied by First Community Village. (Courtesy of the Upper Arlington Historical Society.)

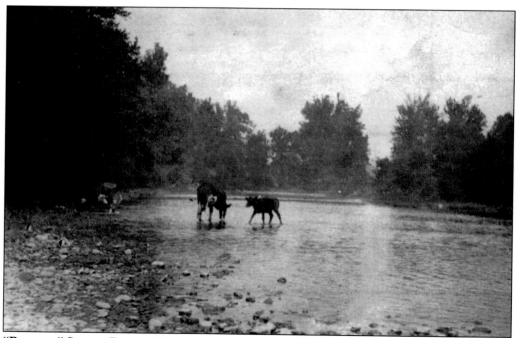

"BUCOLIC" SCIOTO RIVER, 1895. This image showing a cow and her calf was taken looking south on the Scioto River below the future location of the 1905 storage dam. When it was finished, the dam resulted in Griggs Reservoir. (Courtesy of the Upper Arlington Historical Society.)

JAMES T. MILLER FARM. The James T. Miller farm was originally purchased in 1859 by Miller's father in hopes that the country air and lifestyle would improve the health of his young son. The gamble paid off and Miller lived to a ripe old age. The main residence faced west toward the Scioto River and was built in the Italianate style of architecture. It received numerous additions as the family grew and was eventually painted white. (Courtesy of Esther Miller.)

JAMES AND ESTHER MILLER FAMILY, ABOUT 1900. James T. and Esther Everette Miller were the parents of eight children; six girls and two boys. For this image, the family posed on a walkway that connected two of the three hills adjacent to the main house. (Courtesy of Esther Miller.)

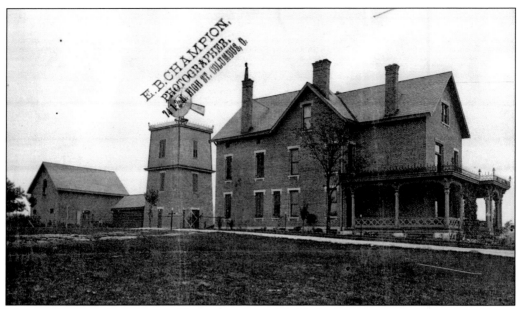

MILLER-HOWARD RESIDENCE. Known as the red brick house, the Miller-Howard residence stood on the south hill overlooking what is now Riverside Drive. Like the James T. Miller house, this residence was equipped with its own outbuildings, including a tank house for storing water and maintaining water pressure. This house was razed in the 1960s; however, First Community Village continues to use one of the brick outbuildings for storage. (Courtesy of Esther Miller.)

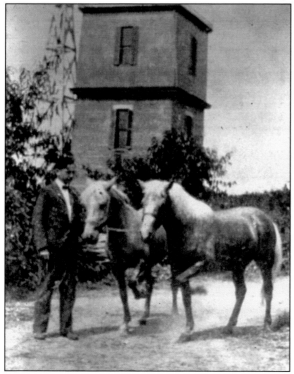

JACK AND JILL. Jack and Jill were a pair of high-stepping carriage ponies owned by the Miller family. This photograph was taken in front of the tank house that served the James T. Miller residence. (Courtesy of the Upper Arlington Historical Society.)

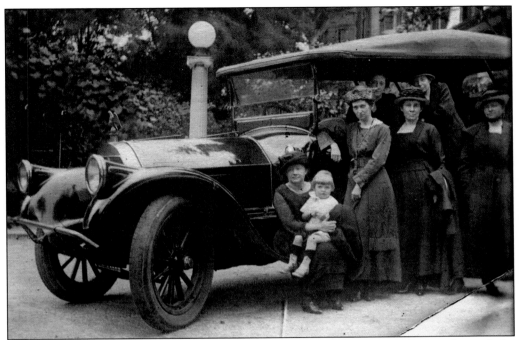

THE MILLER DAUGHTERS AND THE PIERCE ARROW. Taken about 1919, members of the Miller family pose around their Japan black Pierce Arrow touring car. Along with Packard and Peerless, the Pierce Arrow was part of the "Three P's of America's Motordom Elite." In 1918, this car had a new price of $6,650. In today's values, that is equivalent to $90,769. (Courtesy of Esther Miller.)

ARLINGTON, MARBLE CLIFF STATION, ABOUT 1900. The remoteness of the Miller farm in the years after the Civil War combined with the growth of the Arlington community, now called Marble Cliff, made a railroad passenger station on Fifth Avenue viable in the days before automobiles and improved roads. The road intersecting on the extreme right of this image is now an entrance into First Community Village. (Courtesy of the Upper Arlington Historical Society.)

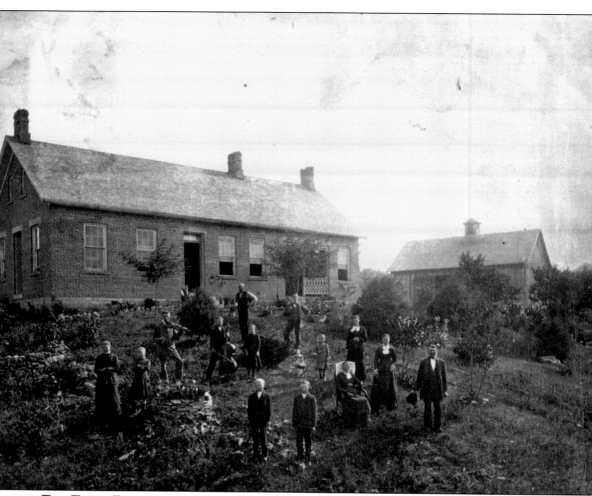

THE TRAPP FAMILY, 1870. The Trapp family home was located near the corner of what is now Riverside Drive and Canterbury Road, approximately where Canterbury village is located. Reinhard Trapp manufactured bricks on the property, many of which were used to line the new dome of the state capital building in downtown Columbus. (Courtesy of the Upper Arlington Historical Society.)

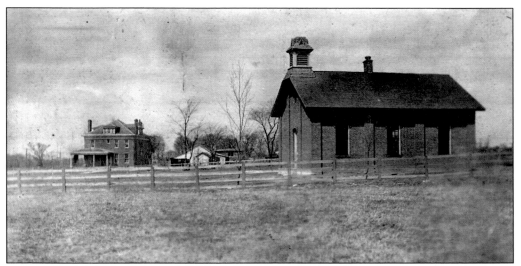

STONY POINT SCHOOL. Stony Point School was one of several one-room schoolhouses operated by Perry Township. Located on the east side of the Scioto River at the intersection of Scioto River Road (now Riverside Drive) and Fishinger Road, the location of the school afforded a sweeping view of the Scioto River plain. The Lakin family's residence (razed after World War II) is in the background. Lakinhurst Road is one of the few reminders of the Lakin family's place in local history. (Courtesy of the Upper Arlington Historical Society, Anna Marie Davidson Drake Collection.)

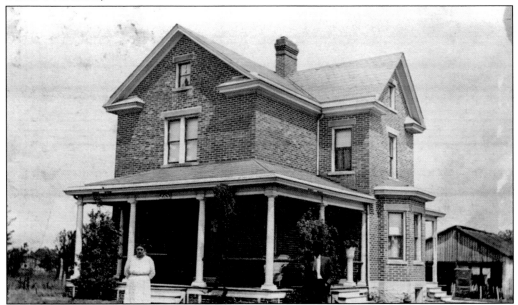

DELASHMUTT RESIDENCE, 1911. The Delashmutt (or DeLashmutt) family lived for many years at what is now 2222 Fishinger Road. The family came to the Fishinger Road area in 1845 when Ebenezer Delashmutt purchased the land on the north side of road. The house in the picture dates to the 1890s. This image from a real-photo postcard was sent as an invitation for the "Richards, McCoy and Delashmutt family reunion," scheduled for August 17, 1911. (Courtesy of Richard Barrett.)

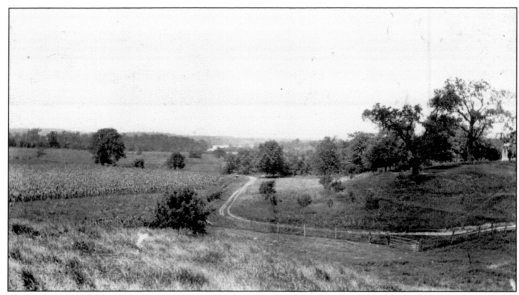

THE SCIOTO RIVER VALLEY, 1900. Taken before the creation of Griggs Dam and Reservoir, this image shows the vast openness of Perry Township in the 1900s from James McCoy's land looking west-northwest. The lane running from the right led to Scioto River Road, now Riverside Drive. (Courtesy of the Upper Arlington Historical Society, Anna Marie Davidson Drake Collection.)

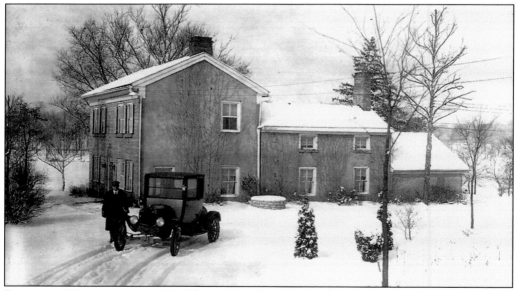

RICHARDS HOUSE, ABOUT 1920. Ebenezer and Lois Richards built their limestone house along the Scioto River in 1814, making it one of the oldest surviving houses in Franklin County. Their daughter Zipporah married James McCoy, beginning the deep ties of the Richards and McCoy families. In 1905 the house became the Dam Tender's House for Griggs Dam. Vacated in the 1990s, it was slated for the wrecking ball but was saved in 2006–2007 through a community effort. (Courtesy of Randy Black.)

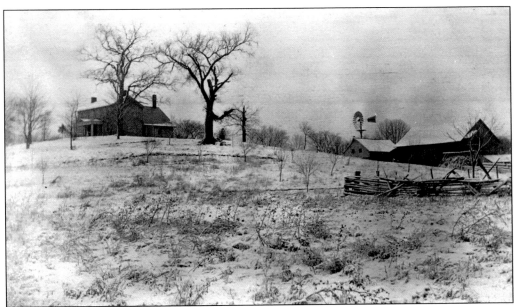

JAMES AND ZIPPORAH McCOY FARMSTEAD. Completed in 1865, the house took 10 years to construct. In 1957, Dave and Carol Ellies purchased the house, then 4500 Riverside Drive, and began the process of restoring it. A subsequent redevelopment of the land around the house by a third party resulted in its current address of 4460 Langport Road. (Courtesy of Carol Ellies Moorehead.)

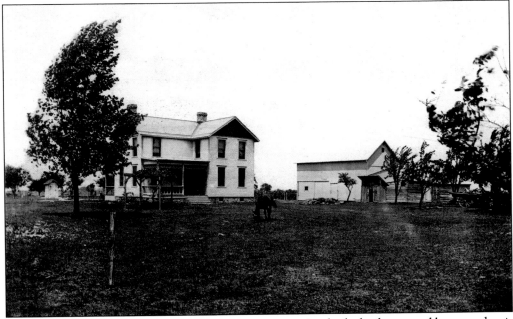

PORTER JAMES McCOY FARM. In 1894, Porter James McCoy built this house and barn at what is now 1988 Lane Road. The land remained a working farm into the 1970s. After the 2007 death of Porter's granddaughter Anna Marie Davidson Drake, the house, barn, and remaining land were sold. (Courtesy of the Upper Arlington Historical Society.)

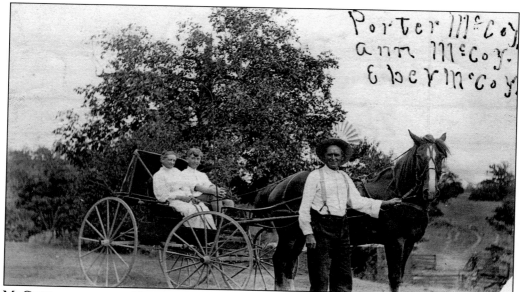

Porter McCoy
ann McCoy.
& ber McCoy

McCoys and their Carriage, about 1911. Porter James McCoy holds the bridle of his horse while his wife, Ann, and son Eber Lakin McCoy watch. It should be noted that Ann, not her teenage son, holds the reins to the horse. (Courtesy of the Upper Arlington Historical Society.)

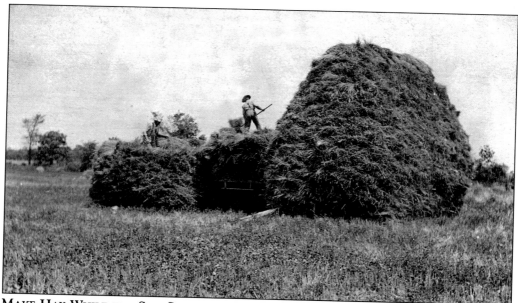

Make Hay While the Sun Shines, about 1910. Porter and his son Eber follow the adage of "make hay while the sun shines." Hay provided early farmers with a variety of uses, including feed, bedding, and straw for making handmade bricks. Freshly cut hay can be ruined by rain, so it was cut when the promise of sunny weather could dry the hay. (Courtesy of the Upper Arlington Historical Society.)

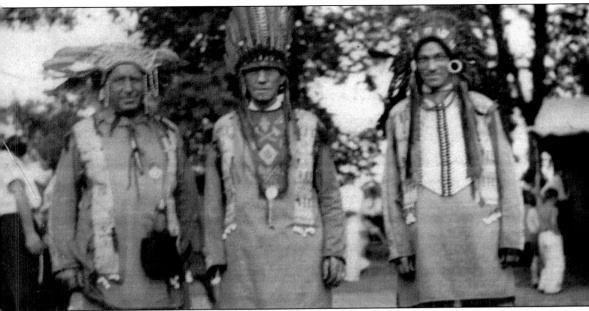

BILL MOOSE, ABOUT 1920. Born in the 1830s, Bill Moose is widely regarded as the last member of the Wyandot tribe to occupy land in the greater Columbus area. Following the white settlement of central Ohio, the Wyandot people were sent to what is now Wyandot County before being pushed west to the Oklahoma Territory. Moose stayed behind and returned to central Ohio. After saving the life of a child in a near accident, the Big Four Railroad gave him permission to settle on a small strip of right-of-way land in Clintonville, immediately south of Morse Road. Moose spent his days trapping, hunting, and walking the land between the Scioto River and his hand-built hut. Following his death in 1937, a marker in his honor was erected at what is now known as Wyandot Hill, overlooking the Scioto Trail. The Scioto Trail, now Riverside Drive, follows the path of the Scioto River from Portsmouth to near Wyandot. From here, Moose and his people could cross a short portage to the Sandusky River and from there travel to Lake Erie in the north. An Ohio historical marker was placed in 2003 near Bill Moose's monument to recognize the Scioto Trail's importance. (Courtesy of the Upper Arlington Historical Society.)

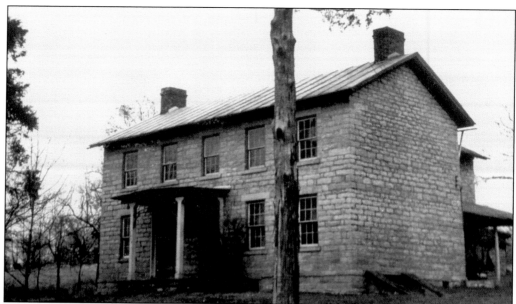

JACOB WRIGHT HOUSE. Jacob Wright was a stonemason from Pennsylvania who came to Perry Township in the 1820s. The quality of Wright's work is evident in the dressing and laying of the stone, which took 10 years. Despite a careful and well-publicized restoration in 1959 by the Whorley family, the house at 5218 Riverside Drive was razed in the 1970s. (Courtesy of David A. Hartmann and the Dublin Historical Society.)

JACOB WRIGHT. Settling in central Ohio in the 1800s, Wright was a stonemason and is credited with building Fletcher Chapel at Riverside Drive and Henderson Road. (Courtesy of David A. Hartmann and the Dublin Historical Society.)

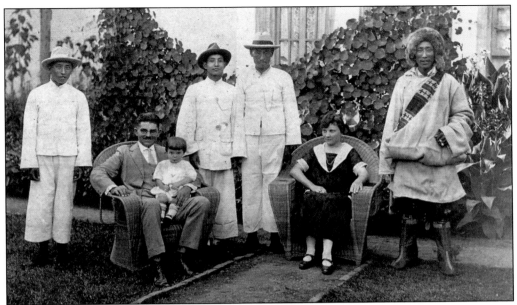

IVAN CHARLES WHORLEY AND FAMILY. After spending his youth in the stone house built by Wright, Ivan Charles Whorley graduated from Stanford University and was among the first medical missionaries granted access to Tibet. Whorley is shown in this Christmas card photograph with his family and members of their Tibetan house staff. He returned to the United States in 1926. (Courtesy of David A. Hartmann and the Dublin Historical Society.)

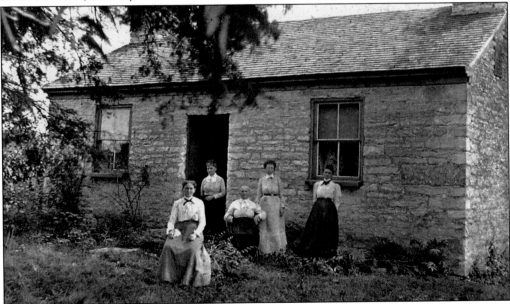

GRANDMOTHER HUTCHINSON'S HOUSE, 1902. Amaziah Hutchinson built this small stone house at what is now 5292 Riverside Drive in 1821 and 1822. The house still remains on its original site. From left to right are Laura Thomas (seated), Nettie Thomas Cook, Kate Hutchinson (seated), Jeanette Thomas, and Sallie Thomas Artz. (Courtesy of David A. Hartmann and the Dublin Historical Society.)

FLETCHER CHAPEL. Now part of a private residence, Fletcher Chapel is located at the southeast corner of Henderson Road and Riverside Drive. The chapel was one of the many early rural Methodist Episcopal chapels following the wildly popular introduction of John Wesley's teachings and beliefs in the 1850s. In the 1920s, Eleanor McMinn oversaw its final conversion into a modern home. (Courtesy of the Upper Arlington Historical Society.)

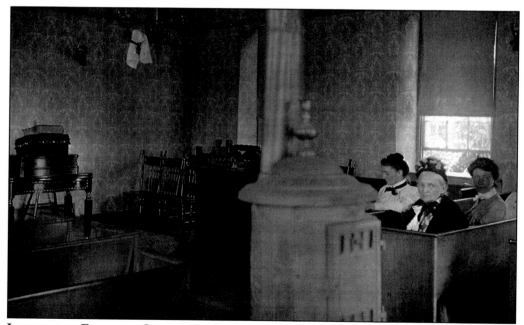

INTERIOR OF FLETCHER CHAPEL. By 1902, the interior of Fletcher Chapel was well appointed given its rural location. In addition to the wallpaper-covered walls were oil lamps and reflectors, a pump organ, and a preacher's pulpit. (Courtesy of David A. Hartmann and the Dublin Historical Society.)

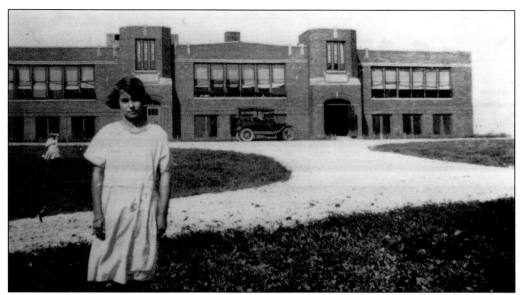

SOUTH PERRY TOWNSHIP SCHOOL, 1920. Hedwig Geyer stands in front of the South Perry Township School on Fishinger Road. Built in 1920, the building was absorbed into the Upper Arlington school system and used into the 1970s before being decommissioned. The building was acquired by the Wellington School in the 1980s and currently houses elementary students. (Courtesy of the Upper Arlington Historical Society, Anna Marie Davidson Drake Collection.)

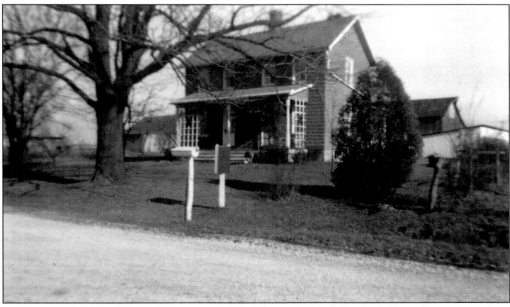

GEYER FARM, 1949. When this picture of the John and Ethel (Corbin) Geyer home was taken in 1949, Reed Road was still a tar-and-gravel country road. The house, which was later assigned the street address of 3876 Reed Road (once known as the Perry Township Free Pike), dated from the late 1800s and was razed in the mid-1960s. (Courtesy of the Upper Arlington Historical Society, Anna Marie Davidson Drake Collection.)

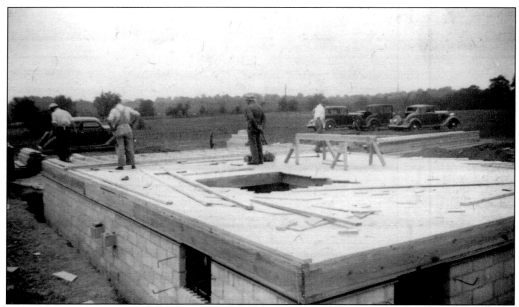

CONSTRUCTION ON THE WARREN C. ARMSTRONG RESIDENCE, 1936. In 1936, Warren and Virginia Armstrong began construction of their home on Edgewood Drive. They built on land purchased from the Lakin family. This view shows how open the former farmland east of Riverside Drive and north of Fishinger Road was before World War II. (Courtesy of Ann Armstrong Knodt.)

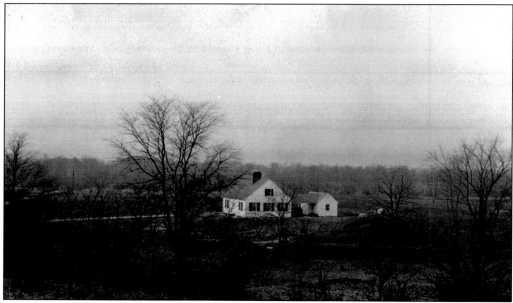

ARMSTRONG RESIDENCE, 1936. The Armstrong residence, on what is now Edgewood Drive, appeared to be quite isolated as the only house standing in its development. The view shows the house looking northwest from what is now Fairlington Drive. The trees in the far distance overlook Griggs Reservoir, and the land to the north of the house is now the site of Lakinhurst Drive. (Courtesy of Ann Armstrong Knodt.)

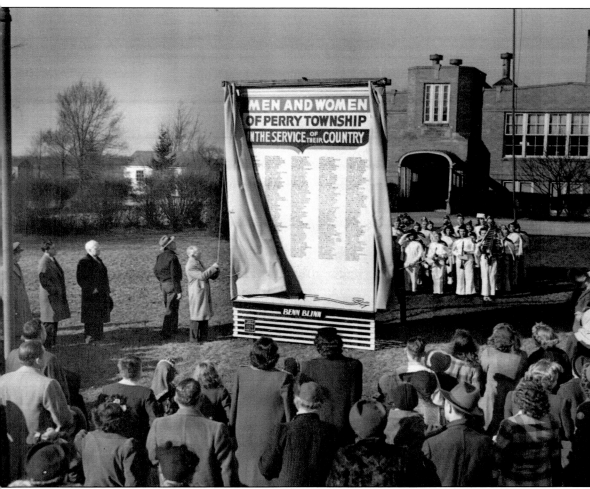

WORLD WAR II SERVICE ROSTER, PERRY TOWNSHIP. Members of the Perry Township south community paused to recognize the men and women who served the U.S. during World War II. The sign, which was erected on the grounds of the school on Fishinger Road, remained up for the duration of the war. (Courtesy of Ann Armstrong Knodt.)

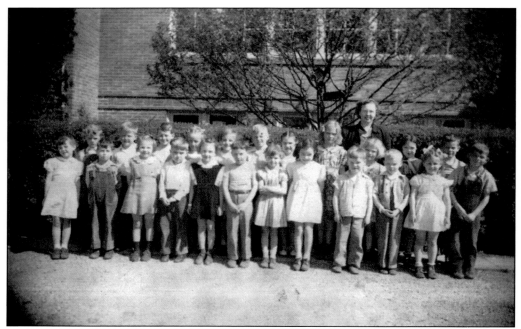

SOUTH PERRY TOWNSHIP FIRST GRADE, 1945–1946. The 23 students in Frances Bowie's first-grade class took a break in their day to stand for a photograph at South Perry Township School in this April 16, 1946, picture. (Courtesy of Ann Armstrong Knodt.)

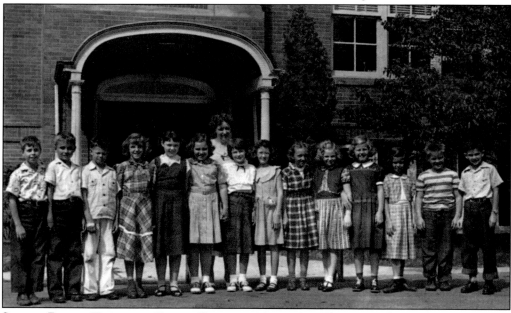

SOUTH PERRY TOWNSHIP FIFTH GRADE, 1949–1950. The 14 students in Mrs. Blieme's fifth-grade class pose outside of the school on Fishinger Road for their school picture. From left to right are Phillip White, Johnny Reed, Delmar Wurzauz, Phyllis Simcox, Marcia Bower, Ann Armstrong, Patty Merckling, Kaye Donoho, Marcy Miller, Patty Ecker, Patty Blackford, Joyce Clark, Lonnie Prince, and Lowell Caldwell. (Courtesy of Ann Armstrong Knodt.)

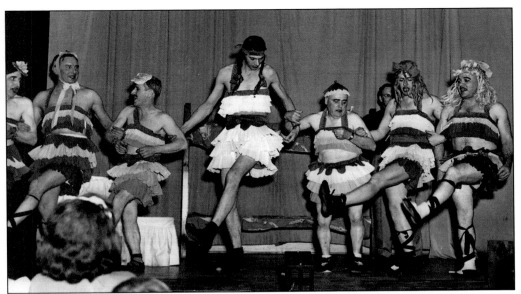

SOUTH PERRY FOLLIES, 1949. As part of the entertainment for a community event, parent-teacher association fathers and the school principal of the South Perry Township School entertained the audience in costume. From left to right the performers are Clair Oberst, Bob Irwin, Lefty Christensen, Herb Hayes, Clarence Salzgaber, school principal Ray Kessler, and Warren C. Armstrong. No record remains of what tune they "hoofed" to. (Courtesy of Ann Armstrong Knodt.)

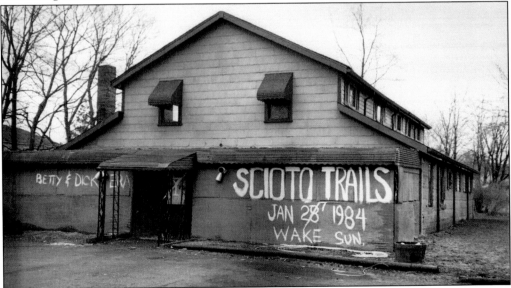

HAPPY SCIOTO TRAILS. If ever there was a rambunctious roadhouse, it was Scioto Trails, a classic beer joint with good food, too. Located on Riverside Drive just north of McCoy Road, it was considered by some to be a nuisance; others considered hanging out there to be very cool. Operated by Dick Dick and his wife, Betty, the Scioto Trails was a hold over from the Perry Township era. Just about anything could happen there, and it usually did, until it closed in 1984. (Courtesy of Robin Lorms.)

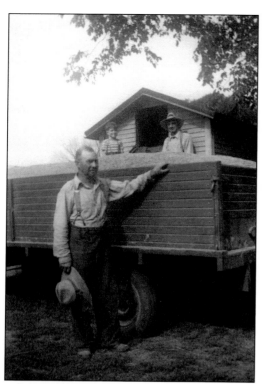

ON THE LANE FARM, AUGUST 1949. Taking a pause from their work duties on the Albert Lane farm are Albert Lane (standing) and Everett Drake. Clarence Davidson, Drake's maternal grandfather, is seated in the grain truck. (Courtesy of the Upper Arlington Historical Society, Anna Marie Davidson Drake Collection.)

KENNY-KENNEDY RESIDENCE. Built by John and Nancy Criswell Kenny beginning in the mid-1830s, the Kenny-Kennedy residence has been owned and occupied by descendents of the Kenny and Kennedy family for over 172 years. Located east of Kenny Road, the house features twin-tied chimneys on both gable ends. (Courtesy of Stuart J. Koblentz.)

Two

CAMP WILLIS

In March 1916, Mexican revolutionary Francisco "Poncho" Villa raided the town of Columbus, New Mexico. The reason for the raid was never determined; however, the reaction from American armed forces stationed on the border was swift. Led by Gen. John "Blackjack" Pershing, American forces embarked on what was called the "Punitive Expedition" into Mexico to search for and capture Villa. Pershing's move left only 5,000 American troops behind to guard the border between the two nations. Following a second raid on American soil, Pres. Woodrow Wilson called up the national guard to bolster the troops on the border. While the call was national, Ohio's outpouring of support for the cause was strong, and men enlisted to support the border troops.

To bring the reservists together in one location, the State of Ohio seized the property owned by the Upper Arlington Company on June 16, 1916, and erected Camp Willis, named for Ohio governor Frank B. Willis. This stopped development in Upper Arlington, stranding the families living in the six occupied houses and the Miller family. All could remain in their homes; however, their movements to and from their residences required gate passes and military escorts.

By September 1, 1916, the camp was nearly empty as troops boarded trains for El Paso, Texas. Thinking that Camp Willis would be made permanent, Ohio poured money into the operation, but the federal government viewed the operation as temporary. When the camp was liquidated, wood from the camp's military buildings was sold for $10 per thousand board feet of lumber. In its wake, Camp Willis left miles of the paved roads, sewer lines, and gas lines laid by the Upper Arlington Company in shambles, and the building began anew.

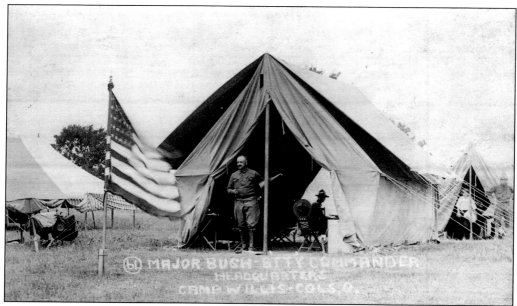

HELLROAR HAROLD. One of the most forceful personalities at Camp Willis was Maj. Harold Monfort Bush, brother of Samuel Prescott Bush of Marble Cliff. Harold was an active recruiter for the cause to protect the border with Mexico and ran a recruiting post from his downtown office. His booming voice and love of military life earned him the nickname "Hellroar Harold" by his troops. (Courtesy of Linda Snashall Cummins.)

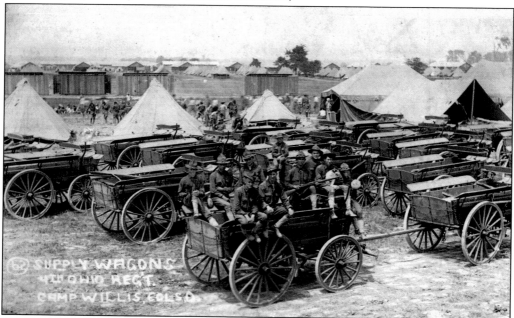

TOO MUCH FOR TOO FEW. Incoming soldiers found wagon loads of unpacked supplies when they arrived at Camp Willis in June 1916. The volume of supplies of military goods overwhelmed the camp in its first weeks. The federal government estimated that it cost $80 to properly outfit one of the soldiers. (Courtesy of Richard Barrett.)

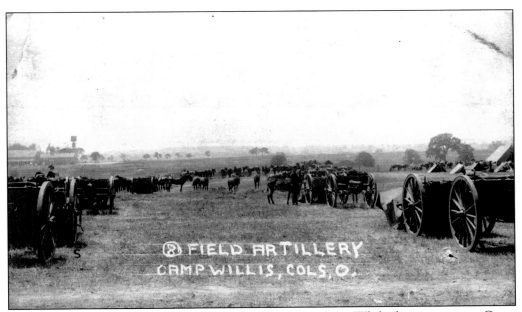

ARTILLERY, TREMONT ROAD AREA, SOUTH OF LANE AVENUE. While the main gate to Camp Willis was located on Fifth Avenue, the artillery was deployed to the northern fields south of Lane Avenue. According to the *History of Upper Arlington*, a few residents along Tremont Road had reported finding concrete slabs on their properties left over from buildings used to serve the troops deployed in the area. (Courtesy of Richard Barrett.)

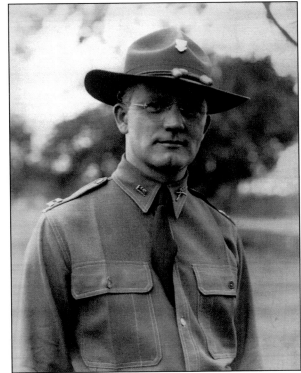

FRANK FORSYTHE. Pictured in his World War I uniform, Frank Forsythe was among the servicemen deployed to Camp Willis for service along the Mexican-American border in 1916. Following his service in the European theater of the "War to End All Wars," Forsythe returned to Upper Arlington and raised a family with his wife Julia. (Courtesy of Julia Forsythe Harrison.)

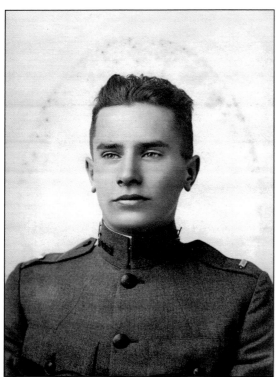

ART SNASHALL. Like Frank Forsythe, Art Snashall was stationed at Camp Willis following Francisco "Poncho" Villa's raid on Columbus, New Mexico, in March 1916. Snashall and his family, including daughter Linda, returned to Upper Arlington to live in the 1940s. (Courtesy of Linda Snashall Cummins.)

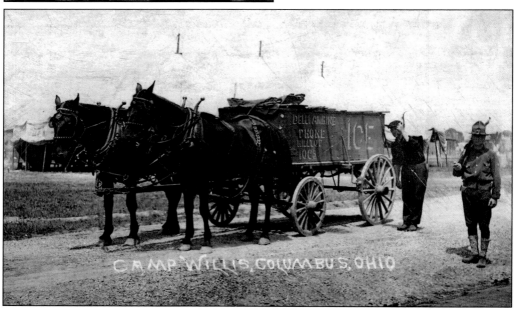

ICE WAGON. Because Camp Willis was erected quickly, and electrical refrigeration was a business still in its infancy, there was no real provision made for modern refrigeration during the 10 weeks that the camp was in full gear. Thus the camp relied on regular ice deliveries for the purpose of keeping food cool. This wagon belonged to Del Amrine's business on the Hilltop, several miles south and west of Camp Willis. (Courtesy of A. W. Wilson.)

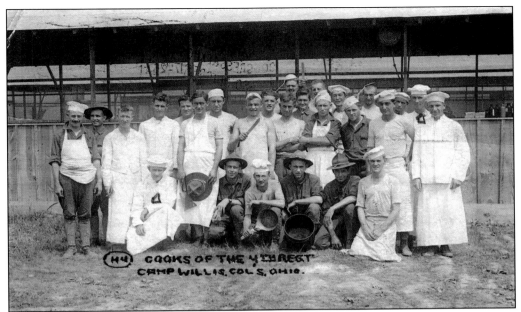

TOO MANY COOKS. An army, Napoleon Bonaparte once pointed out, marches on its stomach. These men were charged with keeping the 4th Regiment fed and happy. One hopes that the gentleman in the back washed the ladle upon his head before using it to serve the next meal. (Courtesy of Richard Barrett.)

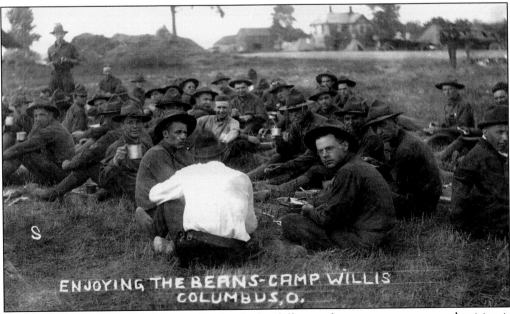

BEANS, BEANS, AND MORE BEANS. Evidently the difference between army mess and cuisine is the same as the difference between the main ingredients and their presentation. For these men, it was a meal of beans served and eaten in the northern fields of Upper Arlington. (Courtesy of Richard Barrett.)

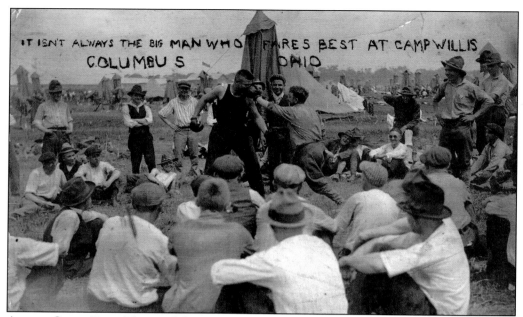

ALL IN GOOD FUN. The need for extensive training combined with a rail strike stalled the movement of troops out of Camp Willis until late August 1916. To kill time, amusements were found in a variety of sources. Escorted visitors were allowed on the camp proper each Sunday. (Courtesy of Richard Barrett.)

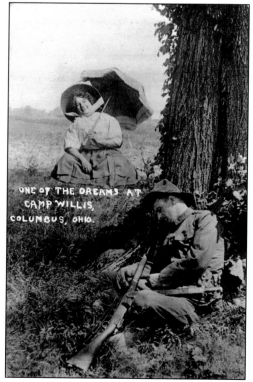

WHEN HE DREAMS. Even the makers of novelty postcards got into the act by publishing postcards highlighting the lighter side of the encampment. (Courtesy of Richard Barrett.)

Three

LIFE IN EARLY UPPER ARLINGTON

Life for early residents of Upper Arlington—the Camp Willis months aside—was one of daily duties. Husbands worked out of the home. Housewives kept household accounts, did the marketing, cooked meals, and watched after the children. They cleaned their own homes without the aid of many of the modern appliances that people in the present take for granted. Electric refrigerators were an expensive luxury until the late 1920s, so many of the early homes were built to accommodate ice boxes that required large blocks of ice to keep foods cool. Likewise, many of the houses built before 1930 were often wired for one telephone, usually in the front hall. More than likely, the telephone line was shared by many households—this was called a "party line"—so calls were kept short, and discussions over the telephone were guarded lest someone was eavesdropping. Letters and postcards were written in those days—even to friends who lived across town. Long-distance telephone calls were expensive and were only made when it was absolutely necessary. If a family had a car, it was a luxury and not the necessity it has become today.

Radio for home entertainment was still in its infancy in 1920, and it was not until the late 1920s that a radio in every living room was a reality for most American households. Therefore, evenings after dinner were spent reading, playing games, or playing the piano. Listening to records played on spring-wound record players was also popular. Children passed the time by doing their homework or playing with one another. To see a movie, one could find out what was playing at the Arlington Theater on West Fifth Avenue, or the family could make the trip to see a film at any number of theaters that operated downtown.

Life remained in this basic pattern until the Great Depression forced some families from their homes or prompted housewives to find work to help support their families. The coming of World War II again disrupted the pattern of daily life for all, while some families made the ultimate sacrifice of losing loved ones. However, Upper Arlington continued to grow, a testament to its planning and its ideals.

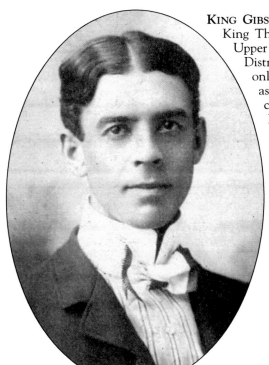

KING GIBSON THOMPSON. Born in Georgetown, Ohio, King Thompson (1876–1960) conceived the idea for Upper Arlington after seeing the Country Club District in Kansas City, Missouri. Thompson not only developed Upper Arlington, but lived there as well, building his family's home on the north corner of Edgemont Road and Cambridge Boulevard. (Courtesy of Dr. Martin P. Sayers and Marjorie Garvin Sayers.)

BENJAMIN SELLS THOMPSON. Benjamin Sells Thompson (1878–1949) cofounded Upper Arlington with his older brother, King. He was also involved in earlier development endeavors with his brother, including projects in the Chittenden, Indianola, Royal Forest, North Ridge, and Indian Springs areas in north Columbus and Clintonville. (Courtesy of Dr. Martin P. Sayers and Marjorie Garvin Sayers.)

UNDEVELOPED TERRAIN, 1913. The Thompson brothers considered developing two parcels of land, one east of Columbus and the other owned by James T. Miller. Miller's property was west of the city and up-wind from Columbus factories. Another deciding force was the rolling terrain, which was a more picturesque seat to locate their community. (Courtesy of the Upper Arlington Historical Society.)

THE BORNHAUSER RESIDENCE. Frank Bornhauser liked a challenge, but he liked a good gamble even more. He was the first to complete a house in the Thompson brothers' Upper Arlington development. The Bornhauser house is located at 1722 Bedford Road. (Courtesy of the Upper Arlington Historical Society.)

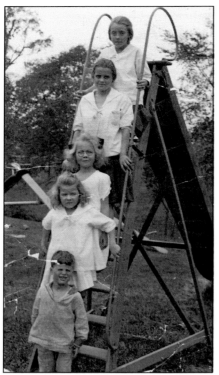

AN ENCHANTED CHILDHOOD. While a small playground was provided at Miller Park, the children of the first Upper Arlington residents found that the vast and growing community provided plenty of opportunities for their adventures while roaming about the undeveloped landscape. (Courtesy of the Upper Arlington Historical Society.)

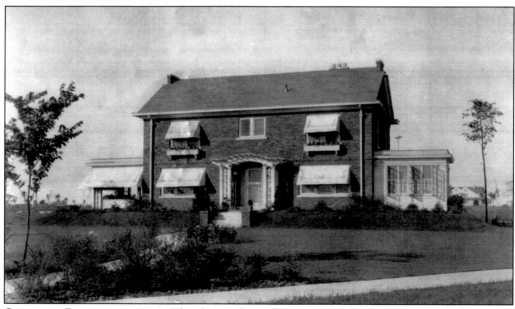

CARMACK RESIDENCE, 1916. The Carmack residence at 1740 Roxbury Road was the fourth house built in Upper Arlington. H. W. Carmack, a regional manager for Whitehouse Coffee, and his wife, Mary Catherine, were the parents of Susan Armstrong, who resided across the street. To the right in the distance is the Orr S. Zimmerman house, which was a quarter mile away from the Carmack home. (Courtesy of Ann Armstrong Knodt.)

BEECHER SHERIDAN, 1916. Alice Fields photographed her cousin Beecher Sheridan standing in front of the Orr S. Zimmerman house at 1790 Cambridge Boulevard (while still under construction) in the late winter of 1916. Sheridan was a traffic engineer and worked with the Upper Arlington Company to lay streets in the community according to the master plan. The Nace residence at the corner of King Avenue and Bedford Road is in the distance. (Courtesy of Virginia Hetrick Dill.)

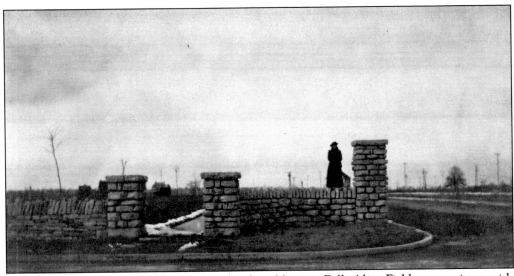

ALICE FIELDS, 1916. According to her daughter Virginia Dill, Alice Fields was smitten with Upper Arlington from the beginning. In March 1916, Fields and her cousin Beecher Sheridan walked about the new, practically empty development. (Courtesy of Virginia Hetrick Dill.)

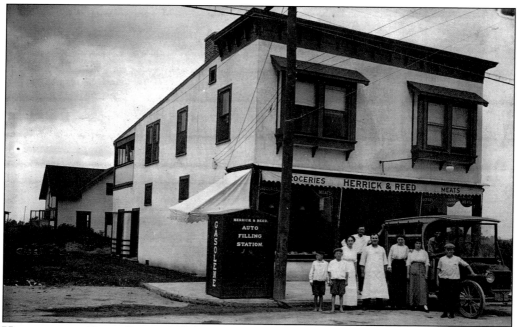

HERRICK AND REED STORE. While not in Upper Arlington proper, the Herrick and Reed Store on the corner of West Fifth Avenue and Wyandotte Road was an early market that served local residents. Stewart Wine Shop later occupied the building for 43 years. (Courtesy of A. W. Wilson.)

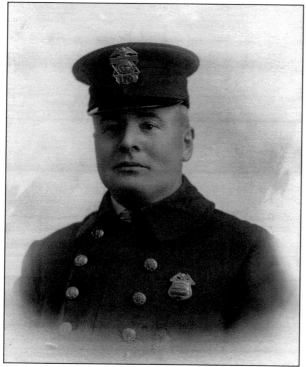

WILLIAM REED. In addition to operating the Herrick and Reed Store at the corner of West Fifth Avenue and Wyandotte Road, William Reed also worked as a police officer in Grandview Heights. Before the creation of the Upper Arlington police force, early families paid Reed to check up on their properties when they were away from home. (Courtesy of A. W. Wilson.)

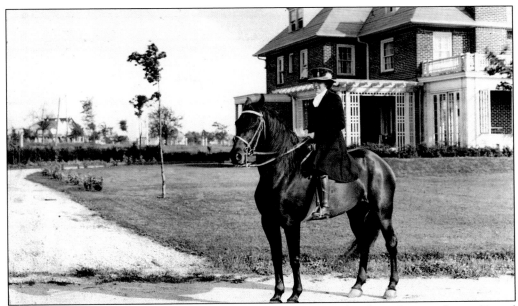

GRACE MILLER ON HORSEBACK, 1918. The youngest of six daughters born to James T. and Esther Everett Miller, Grace Miller paused for a photograph on Stanford Road. The photograph was used on the cover of the July 1918 *Norwester* magazine. The house in the immediate background at 1860 Cambridge Boulevard belonged to her brother Henry Miller. (Courtesy of Esther Miller.)

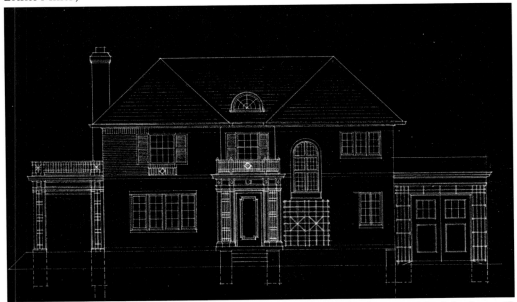

HENRY MILLER HOME BLUEPRINT, 1916. Completed in 1917, this house was built by James T. Miller for his son Henry and his young family. This elevation shows how integral the use of trellis and pergola trim were to the first generation of houses built in Upper Arlington. While this home and many others continue to wear this type of decorative feature, others have had it removed. (Courtesy of Esther Miller.)

Famous for Fourteen Points

1. Upper Arlington is the country club district.
2. Its residents are homeowners, not renters.
3. It is an incorporated village.
4. It is a school district with its own school.
5. No tuition is charged for school advantages.
6. Is governed by commission form of supervision.
7. It is the largest restricted residential district of Columbus.
8. It lies in closer proximity than any other good residence section.
9. Has better auto and street car facilities than any other.
10. Has the best plan for parks and street development and largest acreage.
11. It is unequaled in educational and recreational opportunities.
12. Money will buy more here than in any other community.
13. Guarantees safety in neighborhood and potential increase in values.
14. Does not suffer from smoke and dirt and is ten degrees cooler in summer.

ASK MEMBERS OF OUR SALES ORGANIZATION TO SHOW YOU A HOME!

HERE'S WHO OUR SALESMEN ARE.

Allison, J. A.....................East 1946
Dolin, J. Allen...............Hilltop 2411
Estey, C. H.....................Hilltop 971
Gibbs, Geo. C..................North 7116
Holloway, H. J......East 6917, Auto 9633
Huddleson, C. D..................Office 7462
Hughes, M. L...................North 1941
Joyce, Albert....................Auto 4005
Koebel, Leigh..................Auto 18710
Laird, H. K......Hilltop 3929, Auto 10760

Lawyer, T. Elmer.Auto 12714, North 2945
Mahaffey, E. L.................Hilltop 873
Mauger, H. M..................Hilltop 3709
McCarter, W. L................Hilltop 3043
Nash, Paul.....................North 456
Sieger, A. M........East 3738, Auto 15527
Snyder, Owen T.................East 3425
Shawaker, F. A..Auto 16092, North 4774
Watson, H. G....................East 1963
H. H. Williams.................Auto 13645

H. S. WARWICK, Director of Sales

THE UPPER ARLINGTON COMPANY

Suite 201 Columbus Savings & Trust Bldg.,

Auto 7462-5249, Bell Main 2620-2621

King G. Thompson,
President

Ben S. Thompson,
Secretary-Treasurer

L. P. ALBRIGHT, Mgr. Brokerage Dept.

PROMOTING UPPER ARLINGTON, 1919. As part of its advertising push, the Upper Arlington Company touted the benefits of relocating to the growing suburb. In addition to fresh air and good schools, the company also touted the restricted nature of Upper Arlington's development as a single family, owner-occupied community. (Courtesy of the Upper Arlington Historical Society.)

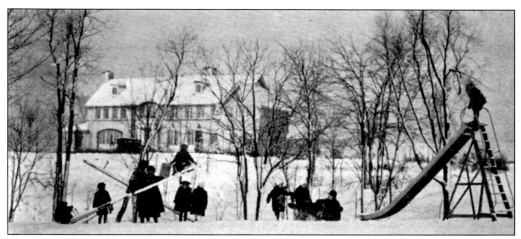

CHILDREN AT PLAY, 1919. Children play in the snow in this image dating from 1919 that appeared in the *Norwester* magazine. In the background is the King Thompson residence on the corner of Cambridge Boulevard and Edgemont Road. (Courtesy of the Upper Arlington Historical Society.)

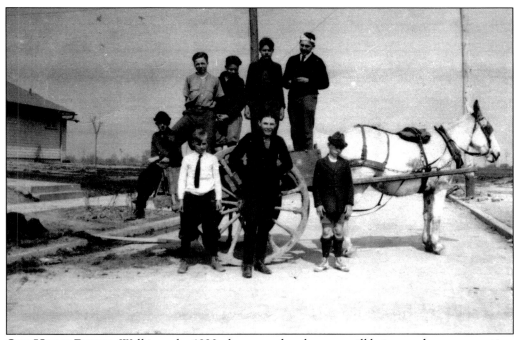

ONE HORSE POWER. Well into the 1920s, horses and mules were still being used on construction sites, including in Upper Arlington. These youngsters clown for the camera while aboard a two-wheel cart. (Courtesy of the Upper Arlington Historical Society.)

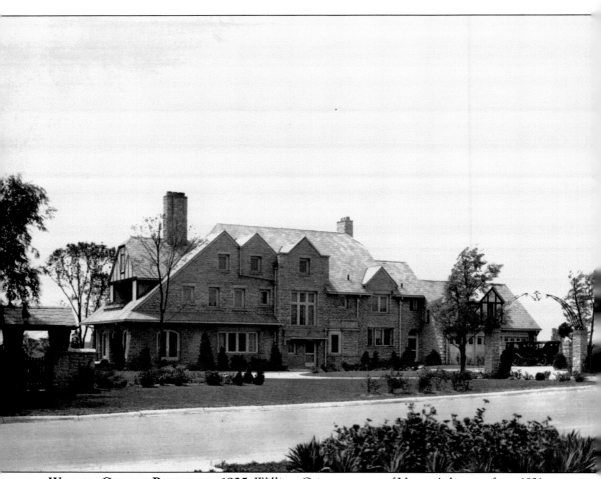

WILLIAM GRIEVES RESIDENCE, 1925. William Grieves, mayor of Upper Arlington from 1921 to 1924, chose the property at 2489 Tremont Road for his second Upper Arlington residence. It was completed in 1923. The house is attributed to architect Charles Inscho, who served as the first president of the Columbus chapter of the American Institute of Architects. Inscho is thought to be the architect of the Grieves family's original house in Upper Arlington at 2094 Edgemont Road. Grieves, who was also secretary of Jeffrey Manufacturing Company, sold the above house before his second marriage. (Courtesy of the Dawson family.)

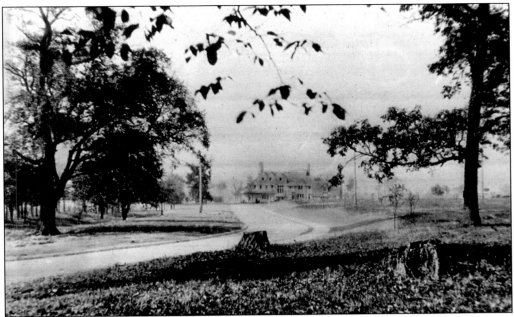

PARKWAY NORTH, ABOUT 1923. In the mid-1920s, the vistas in the largely undeveloped Parkway Drive area were open and afforded this view looking along Parkway Drive toward Tremont Road. The lone house in the distance is the Grieves residence at 2489 Tremont Road. (Courtesy of the Upper Arlington Historical Society.)

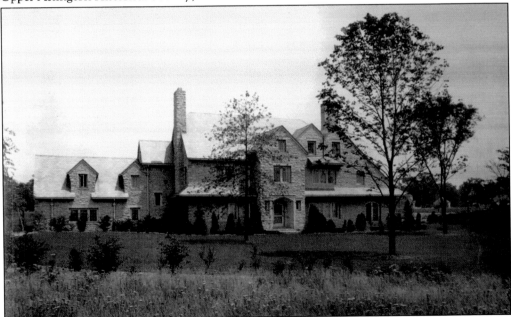

GRIEVES RESIDENCE, WEST FACADE, 1925. It is interesting to note that the traditional front facade of the Grieves house faced westward toward Scioto Country Club to afford the home's public rooms greater views of the golf course. Doing so left what would otherwise be the back facade of the house to face Tremont Road. (Courtesy of the Dawson family.)

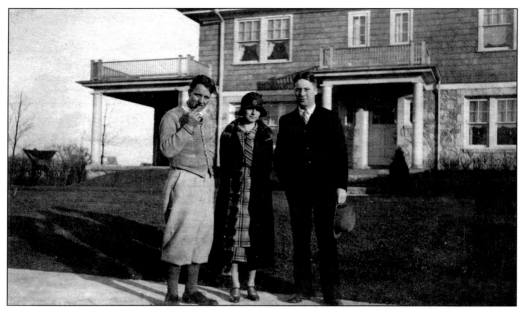

BOB FIELD AND FRIENDS, 1927. From left to right, Bob Field, Fran Miller, and Norman Reed stand in front the Field family residence at 2061 Waltham Road. Field's parents were Dennis and Emma Field. The home's facade has since been heavily altered with the addition of a two story plantation-style gallery across the front of the structure. (Courtesy of A. W. Wilson.)

HATTIE DIERDORF IN HER GARDEN, 1927. Harriett (Hattie) Dierdorf poses in the flower garden behind her home at 2064 Waltham Road. Her attire, proper for a housewife of the era, included her day cotton dress, which was suitable for light housework, hose, and medium-heel shoes. If she needed to go to the store, she had to change into a suitable dress, accessorized with matching shoes and a hat. (Courtesy of Stuart J. Koblentz.)

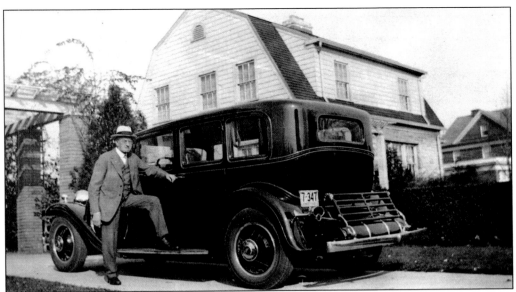

HENRY BEECHER DIERDORF, 1931. Henry Beecher Dierdorf poses with his new 1932 LaSalle Imperial seven-passenger sedan in the driveway of his home on Waltham Road. Dierdorf was plant superintendent for Jeffrey Manufacturing Company; his engineering accomplishments and patents included the first successful use of electric motor-driven mining equipment. The Roy Francis residence, heavily modified since this picture, is in the background. (Courtesy of Stuart J. Koblentz.)

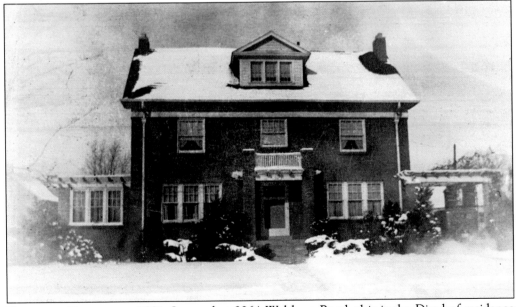

DIERDORF RESIDENCE, 1931. Located at 2064 Waltham Road, this is the Dierdorf residence during the winter of 1931. The house is an example of how a Colonial Revival house was adapted to Upper Arlington's English garden theme with the addition of pergola around the sunroom and front porch. The porte cochere on the east side of the house was built in the pergola style as well. (Courtesy of Stuart J. Koblentz.)

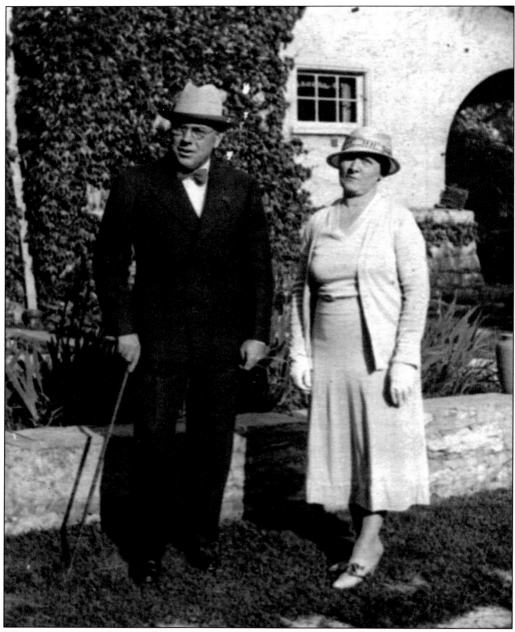

WARREN A. AND SUSAN ARMSTRONG, ABOUT 1935. Among the first six families to move into Upper Arlington were Warren and Susan Carmack Armstrong. Warren, who worked for the Upper Arlington Company, also served on the village council. The couple's son Warren C. served as mayor from 1959 to 1964. (Courtesy of Ann Armstrong Knodt.)

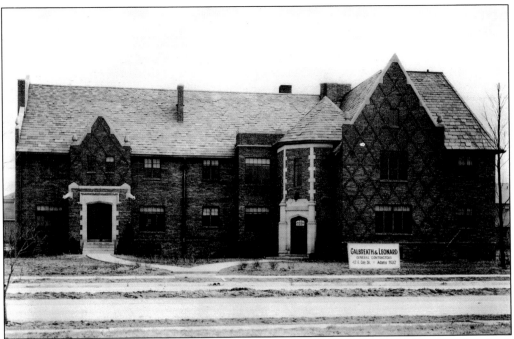

SUFFOLK ROAD APARTMENT, 1927. While rental units were not part of the Thompson brother's original layout, by the mid-1920s, apartment construction was permitted, providing the designs lived up to Upper Arlington standards. This building, built by Galbreath and Leonard General Contractors, featured spacious floor plans for the era and ornamented brick work to capture an Old World feeling. (Courtesy of Nancy Rundels.)

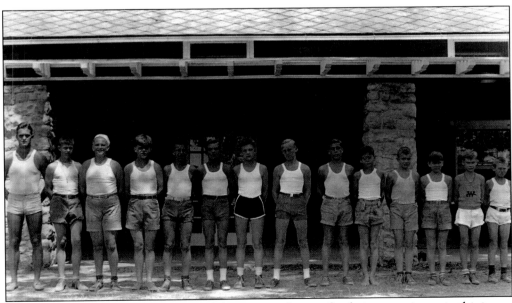

CAMP WILSON, INDIAN LAKE. Upper Arlington youths pose for their camp picture in this image from 1935. Willis Hodges is sixth from the left. (Courtesy of Dr. Willis Hodges and family.)

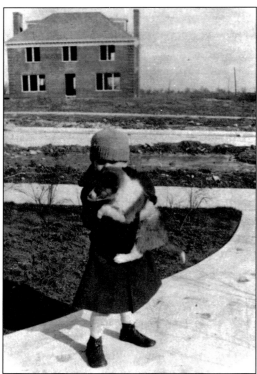

LITTLE MISS MOFFETT AND FRIEND, ABOUT 1920. A very young Jean Moffett was photographed across the street from the construction of her family's home at 2080 Tremont Road. (Courtesy of the Upper Arlington Historical Society.)

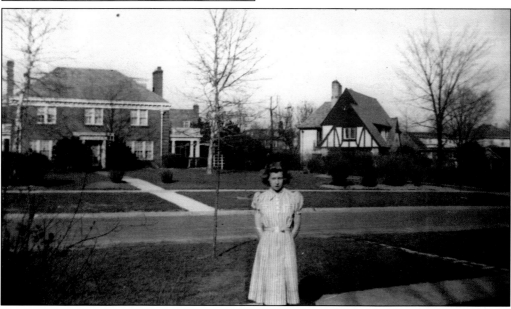

GROWING UP TOGETHER. Some 17 years after the photograph above was taken, Moffett was again photographed in front of her home, showing not only how she had grown, but also how the neighborhood around her had grown. The house to the right of her is the John Galbreath family home on the corner of Guilford and Tremont Roads. (Courtesy of the Upper Arlington Historical Society.)

SLEDDING ON BEDFORD ROAD, 1940. Sarah and Susan Knell pause for their picture while playing with a sled in the front yard of their home at 1811 Bedford Road. In the background is construction of the Perry Denune residence at 1845 Tremont Road. (Courtesy of the Knell family.)

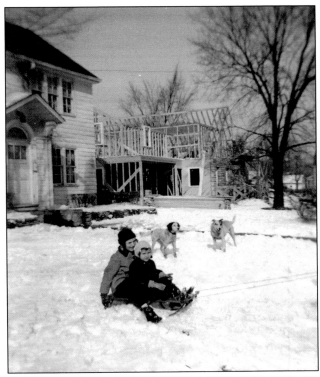

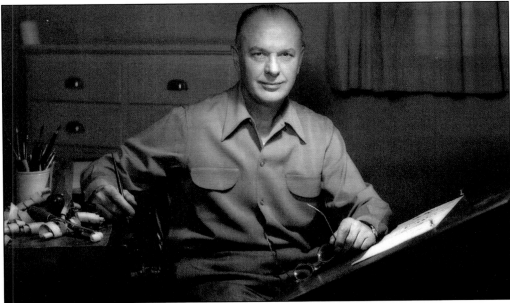

DUDLEY FISHER. Nationally syndicated cartoonist Dudley Fisher made Upper Arlington home from the 1920s until his death in 1951. Among Fisher's creations were Skylark, a Sunday full-page cartoon that featured central Ohio communities for the *Columbus Dispatch*; Right Around Home; and Myrtle, which appeared nationally through King Features Syndicate. (The Ohio State University Cartoon Research Library; Dudley Fisher Collection.)

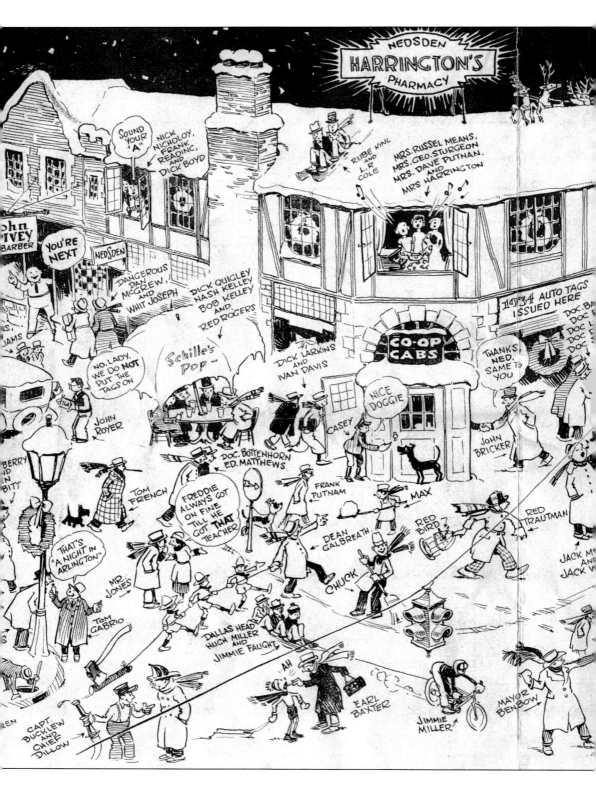

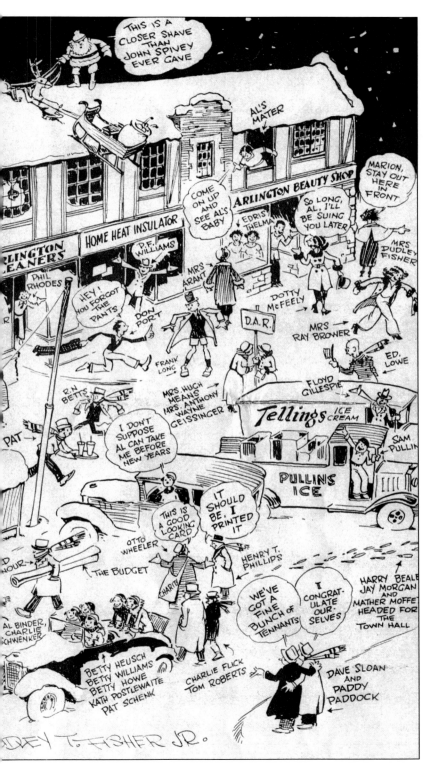

RIGHT AROUND UPPER ARLINGTON. In the 1920s, Dudley Fisher created Skylark, a full-page cartoon for the Sunday *Columbus Dispatch*. Skylark included aerial maps of various communities in central Ohio as well as characters and notables from the community at large. Using this concept, Fisher created this double-page cartoon of the business section located at Arlington Avenue and Guilford Road. The scene is populated with locals going about their business. Fisher included his wife in the upper right corner, who is giving instructions to the couple's daughter Marion. (Courtesy of the Upper Arlington Civic Association.)

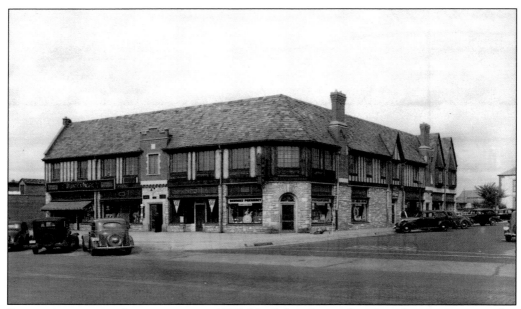

SHOPS, ARLINGTON AVENUE, ABOUT 1935. Until the advent of modern shopping centers after World War II, Upper Arlington residents relied upon the convenience of the commercial stores along Arlington Avenue for food and other daily necessities. The north building at the Mallway and Arlington Avenue boasted an A&P market and Bowrons Pharmacy as well as a doctor and a dentist. (Courtesy of the Ohio Historical Society, Columbus Dispatch Collection.)

MILLER PARK, 1939. This aerial image of Miller Park shows the quiet streets of Upper Arlington in 1939. The view, looking southwest, also shows the rooftops of the white Miller house and the red Miller-Howard residence. (Courtesy of the Upper Arlington Historical Society.)

Four

SUBURB SUPERB

Old Arlington, or the Country Club District as it was known in early brochures by the Upper Arlington Company, is significant as an early-20th-century planned community—one of the first in the nation. Designed by noted landscape architect William Pitkin Jr. of Rochester, New York, the community exhibits the urban planning principals of the garden city movement. The movement, which was influencing neighborhood design across the country in the 1920s, promoted the integration of architecture, landscape architecture, and urban planning. The concepts of streets conforming to the contours of the land, permanent open spaces, extensive landscaping, designated setbacks, and architectural controls so characteristic of the garden city movement, were not in general use in the country at this time. The Upper Arlington historic district, stretching from West Fifth Avenue to Lane Avenue and from Riverside Drive to Andover Road, with its curvilinear streets, integral parks and schools, civic center, golf course, and landscaped openness, is a significant early example of such a community.

The Upper Arlington historic district is also significant for its wonderful collection of early 20th century revival-style architecture. The architecture reflects design influences, features, and decorative elements popular during the 18th and 19th centuries—thus the term revival. Houses of Cape Cod, Colonial, Federal, Georgian, Tudor, Dutch, French, English, and Spanish Revival styles are all represented, many designed by prominent local architects including Miller and Reeves, Ray Sims, Downey Moore, Charles Inscho, and Howard Dwight Smith.

In 1985, the original portion of Upper Arlington was placed on the National Register of Historic Places, the country's official list of cultural resources worthy of preservation due to their local, state, or national significance. This distinction was the result of a two-year effort by a committee of approximately 25 residents led by Joanne Duran. The 536-acre district encompasses over 1,100 buildings, approximately 950 of which are contributing structures.

The complimentary styles, scale, materials, heights, and proportions of these homes and buildings continue to contribute to the charm and character of Old Arlington, which the Thompson brothers promoted as the "Suburb Superb."

In 2003, the Ohio Bicentennial Commission placed an Ohio historical marker at Miller Park to recognize this important area.

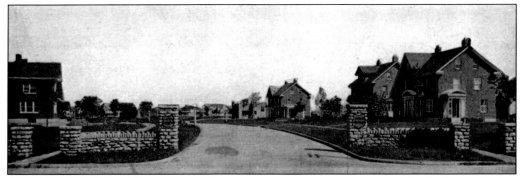

GATES TO PARADISE. These stone pillars were welcome into the community at the beginning of its development and continue to signify the entrance into the Upper Arlington historic district. In 1985, when the district was added to the National Register of Historic Places, a brass plaque was placed on the front of one of the pillars. (Courtesy of the Upper Arlington Historical Society.)

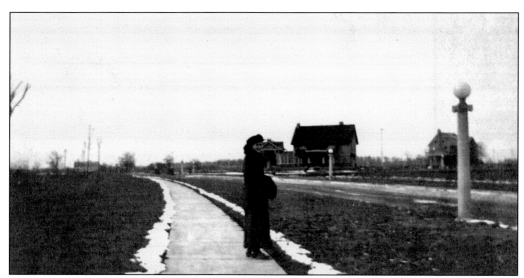

ANTICIPATION. In March 1916, Alice Fields and her cousin Beecher Sheridan visited the promising Country Club District. Streets and sidewalks are laid, the streetlights are installed, and the development is ready for houses to be built. Fields looks lonely standing on Cambridge Boulevard. (Courtesy of Virginia Hetrick Dill.)

LIGHTING THE WAY. The street lights chosen for the new development were made of poured concrete topped with a white globe. The lampposts were ionic columns. Over the years, they were replaced with cast-metal streetlights, but the last surviving one can still be seen near the Miller Ice House at First Community Village. (Courtesy of Virginia Hetrick Dill.)

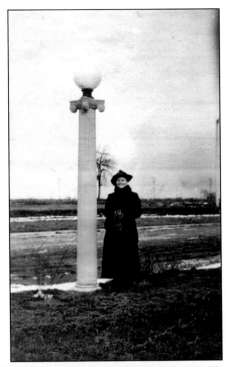

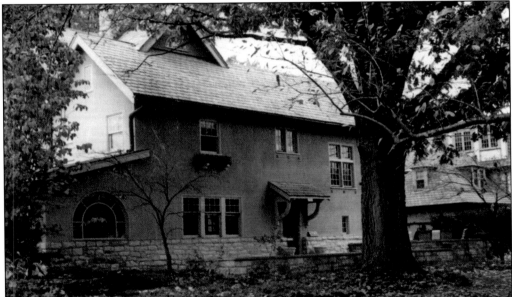

ARTS AND CRAFTS OR CRAFTSMAN AT 1761 ROXBURY ROAD. This style was developed during the early 20th century as part of a renewed interest in artistry and craftsmanship in building design. The designs often featured overhanging, gabled rooflines, sometimes with simple brackets; materials with different textures, including brick, stone, stucco, or clapboards (sometimes used together); combinations of window groupings; and an altogether rustic, informal appearance. (Courtesy of Stuart J. Koblentz.)

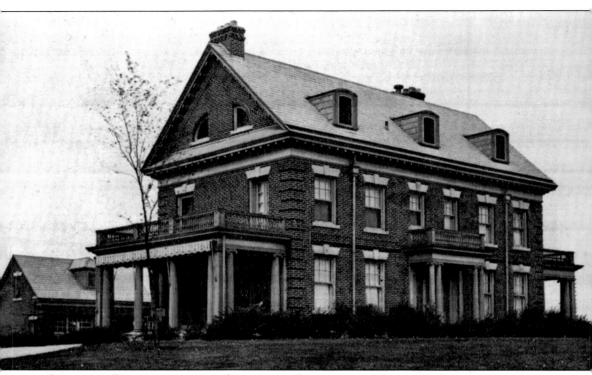

GEORGIAN REVIVAL AT 1919 CAMBRIDGE BOULEVARD. The original Georgian style was fashioned after those developed in England during the reigns of all four King Georges and built along the American East Coast in the early 1700s. These gracious homes are known for their simple exterior lines and few decorative devices. The two or three story, usually brick home is rectangular with a chimney at each end. This home was designed by Marriott, Allen and Hall in 1915 for Upper Arlington cofounder Ben Thompson. The third floor has a ballroom where Thompson's wife hosted community women who sewed bandages for the Red Cross during World War I. (Courtesy of the Upper Arlington Historical Society.)

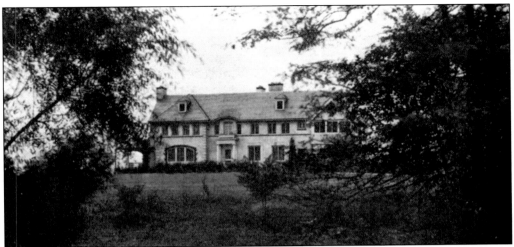

HOME OF KING THOMPSON AT 1930 CAMBRIDGE BOULEVARD. This view of the King Thompson home is from the ravine below. Although it has a Cambridge Boulevard address, the house actually faces Edgemont Road. Recently the adjourning property on Cambridge Boulevard was purchased and the lot was returned to a garden like it was in the days of Ethel Thompson. (Courtesy of the Upper Arlington Historical Society.)

ENGLISH TUDOR REVIVAL AT 1685 ANDOVER ROAD. This style was named after the House of Tudor in England where the original exposed wooden beams were used to hold up the structure. The half-timbering in Tudor Revival homes is decorative and filled with plaster and stucco, brick, or stone. They are usually two or two-and-a-half stories, often with diamond shaped, leaded glass-paned windows. The massive decorative brick chimneys, often on the facade, are sometimes topped with terra-cotta chimney pots. This home was designed by Barnhart-Seiller and built in 1931. (Courtesy of the Upper Arlington Historical Society.)

FEDERAL REVIVAL AT 1771 CAMBRIDGE BOULEVARD. Encompassing classical Greek and Roman elements, Federal Revival structures were influenced by the simple lines reflected in homes designed by architects such as Thomas Jefferson. There is usually a flat facade and ornamentation that encompasses classical Greek and Roman features. (Courtesy of the Upper Arlington Historical Society.)

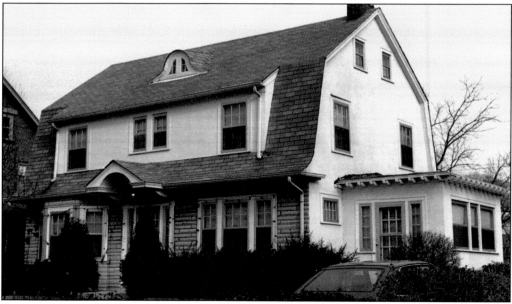

DUTCH COLONIAL REVIVAL AT 1716 BEDFORD ROAD. Contrary to its name, this style did not originate in the Netherlands but in the United States with early German settlers in Pennsylvania in the 1600s. These houses are moderate size and two or two-and-a-half stories, with a gambrel roof and flaring eaves that extend over the porches, creating a barn-like impression. There is usually a central entrance and one long dormer with several windows through the roof. (Courtesy of the Upper Arlington Historical Society.)

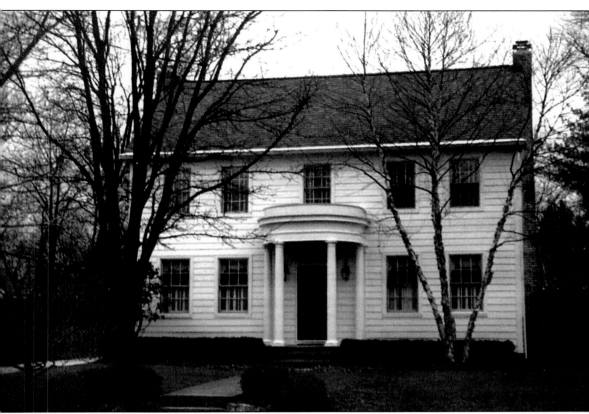

NEW ENGLAND COLONIAL REVIVAL AT 1950 ARLINGTON AVENUE. Fashioned after early houses in New England, these homes are two-and-a-half stories with a central hallway. These houses have symmetrical facades, few projections, and often include elaborate cornices. Exteriors are faced with narrow or wide clapboard siding but can be sided with brick and stone. Howard Dwight Smith designed this house in 1920. He is best known as the architect of Ohio Stadium. (Courtesy of the Upper Arlington Historical Society.)

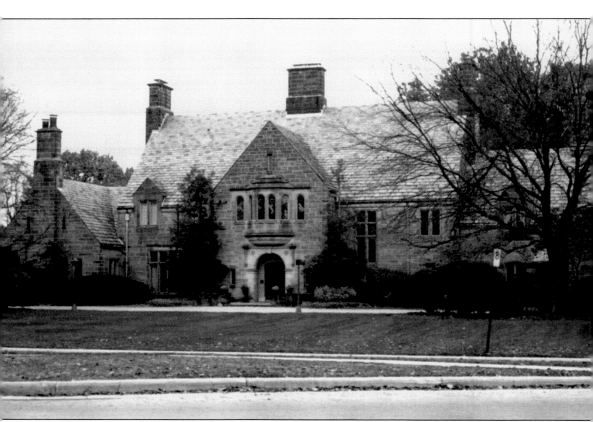

ENGLISH COUNTRY REVIVAL, 2427 TREMONT ROAD. These imposing-looking stone houses, sometimes referred to as "Cottswald" style, are usually two or two-and-a-half stories with steeply-pitched gable roofs. It is not uncommon to find on these types of revival houses that the slates for the roofs are placed with greatest surface exposure low on the roof area, and grow narrower as the rows of slates reach up towards the ridgeline of the roof. In doing so the slates help to add an optical illusion that the roof area is larger and steeper than it is. The multiple windows are often leaded glass and the multiple chimneys are often topped with terra cotta chimney pots. The house featured in this image was built by George and Mary Chennell between 1931 and 1933. George had the house designed in a style that reminded him of his native village in England. The couple moved into their home in the late summer of 1933, but their tenure was short lived. George died of natural causes a little over three months after occupying the house. Mary Chennell never fully recovered from the shock of her husband's death and died at the house in the spring of 1934. (Courtesy of the Upper Arlington Historical Society.)

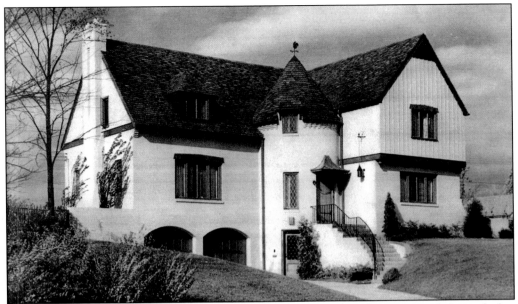

FRENCH NORMANDY REVIVAL AT 2176 NORTH PARKWAY. These houses were fashioned after homes in the Normandy province of France where the house and barn were combined into one building. The front turret resembled a silo where grain was stored, and in the revival style it serves as the entrance. This home was designed by Robert R. Royce and built in 1932. (Courtesy of the Upper Arlington Historical Society.)

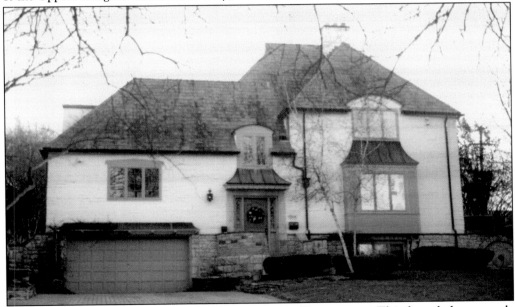

FRENCH PROVINCIAL REVIVAL AT 2237 CAMBRIDGE BOULEVARD. This formal chateau-style home is known for its steep, high, hip roof and protruding French window. It is one-and-a-half to two-and-a-half stories, and often the second story windows have a curved head that breaks through the cornice. Siding is often a combination of stucco with brick or stone. This 1937 home was designed by Robert R. Royce. (Courtesy of the Upper Arlington Historical Society.)

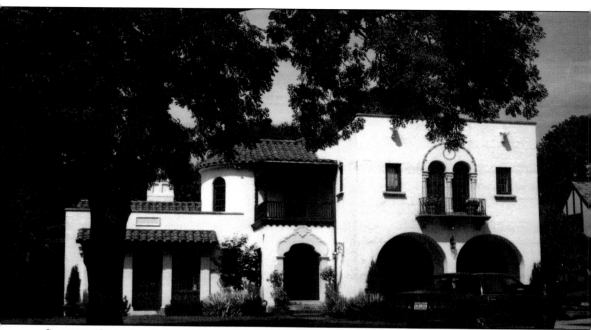

SPANISH COLONIAL OR MEDITERRANEAN REVIVAL AT 2459 TREMONT ROAD. Stucco walls and low-pitched clay tile roofs are hallmarks of the Spanish Colonial Revival or Mediterranean Revival styles. Popularized in California during the early 1900s, the style also made use of arched openings, ceramic tile detail, and iron-fronted balconies. Before it was demolished in 2001, this house had three fountains and hand-painted tiles purchased by the owner in Italy. Most of one wall of the living room was a floor-to-ceiling, clear, stained-glass window of a ship. This house was designed by Charles Inscho in 1937. (Courtesy of the Upper Arlington Historical Society.)

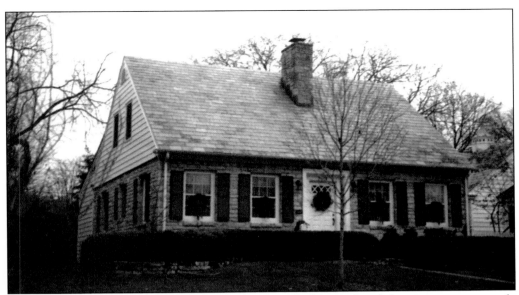

Cape Cod Revival at 2018 Coventry. The Cape Cod Revival–style home was an extremely popular and affordable home in the United States from the 1920s through the 1950s. Based upon the saltbox-type house of the early colonists in New England, the original versions had low central chimneys, but many revival-style designs have end chimneys. There is usually a central entrance, and the steeply pitched, gabled roof is shingled. The windows are usually framed by shutters. (Courtesy of the Upper Arlington Historical Society.)

The Norwester. To help promote Upper Arlington and to help neighbors meet one another, the *Norwester* magazine was born. Published from 1917 to 1922, each issue of the *Norwester* featured personality profiles and news articles about residents and household topics. This issue features an artist's take on the Upper Arlington Company land office at Miller Park. The building pictured here still forms the nucleus of the Upper Arlington Public Library Miller Park Branch. (Courtesy of the Upper Arlington Historical Society.)

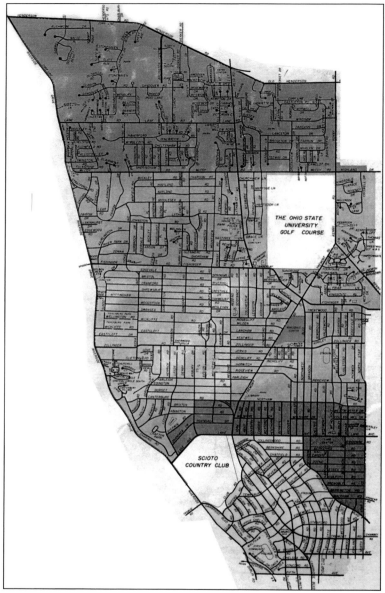

ON THE GROW WITH UPPER ARLINGTON. Neighborhood development in Upper Arlington evolved as lands were annexed northward. Each area reflects the community planning trends of the time, and most included a shopping center. The community started across West Fifth Avenue from Grandview Heights in what was then called the Country Club District, with wide lots, curvilinear streets and revival style homes. The Canterbury Addition was developed in the 1940s and 1950s with deed restrictions, which limited homes to ranch-style architecture. The grid design of neighborhoods with uniform lots was developed during the post–World War II era when returning servicemen were looking for affordable housing. Newer developments, from McCoy Road north to Henderson Road, began in the mid-1970s and continues today with cul de sacs. Many these areas retain the feel of the countryside. Just a short time ago it was farmland seemingly miles "out in the country." (Courtesy of the Upper Arlington Historical Society.)

Five

Upper Arlington in the Atomic Age

In 2007, the first baby boomer in the United States applied for Social Security retirement benefits. While those who are a part of that generation may find it hard to believe, the memories that may seem like yesterday are 30, 40, or 50 years old.

In one generation, Upper Arlington had undergone some of its greatest changes. Following the end of World War II, rapid expansion of the housing stock north of Lane Avenue reached further north, with a wider variety of housing options than the Thompson brothers could have ever imagined possible. The rise of the Ridge neighborhood north of Zollinger Road provided many World War II soldiers with the capabilities of attaining the American dream of home ownership.

Changes in shopping patterns and the rise of the two-car family gave birth to strip mall shopping centers on Lane Avenue and Tremont Road. Even those shopping centers have had to modernize and adapt to changing consumer patterns. The current Shops at Lane Avenue began life as Lane Shopping Center in the 1950s. It boasted a Big Bear supermarket, a movie theater, and a two-floor G. C. Murphy and Company five and dime store. In the 1970s, Lane Shopping Center was remodeled into Columbus's first upscale, enclosed shopping mall, boasting Montaldo's, Little Professor Book Center, and one of the first food courts in Franklin County. In 2004, the aging mall was taken back to what it first was, a shopping center featuring upscale stores.

Like the shopping district on Lane Avenue, Upper Arlington has shown the same type of resilience. Its mix of neighborhoods and a wide variety of housing stock has allowed it to maintain its place as one of the premiere communities in central Ohio.

WALTHAM ROAD APARTMENTS, 1946.
Linda Snashall Cummins's parents were
among the first wave of residents that moved
into the newly completed Waltham Road
Apartment area following the end of World
War II. The buildings were developed by
builder Carl Hadley. The designs mimicked
Georgian Revival elements; however,
their features were modern for the times.
(Courtesy of Linda Snashall Cummins.)

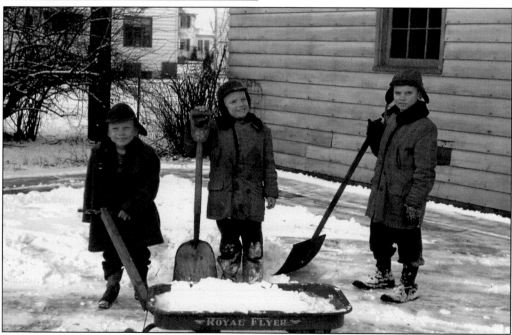

SCHOEDINGER'S SNOW REMOVAL SERVICE. From left to right, Steven, David, and Jay Schoedinger
all helped to remove snow from around their home following the snowstorm of 1950. (Courtesy
of the Schoedinger family.)

SAYERS FAMILY MOVES IN. Following his neurosurgical training in Philadelphia, Dr. Martin Peter Sayers and his family returned to Columbus. The family rented 2251 Dorset Road, pending the construction of their home on Canterbury Lane. (Courtesy of Dr. Martin P Sayers and Marjorie Garvin Sayers.)

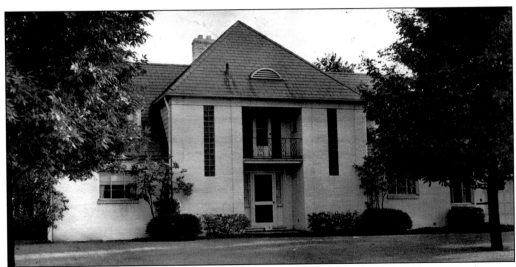

ERWIN DREESE RESIDENCE, 1951. Designed by Robert R. Royce, the Erwin Dreese residence at 2419 Onandaga Road melded a number of styles into a unique facade—one that incorporated brick, iron, glass block, and slate. The Ohio State University had Dreese serving as the second chair of the electrical engineering department. Dreese Laboratory on campus is named in his honor. (Courtesy of the Upper Arlington Historical Society.)

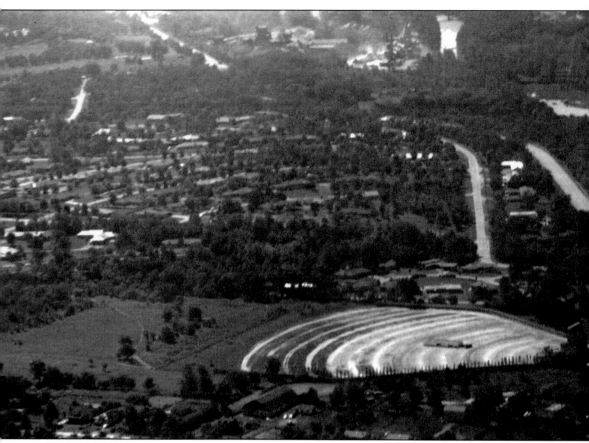

MILES DRIVE-IN THEATER, 1951. This aerial image was taken by Dr. John P. Garvin in 1951 and shows, from right to left, Riverside Drive and Charing Road looking south. In the foreground is Miles Drive-In Theater. In the distance at the top of the image is Scioto Country Club. (Courtesy of Dr. Martin P Sayers and Marjorie Garvin Sayers.)

PORTER RESIDENCE. Designed by Robert R. Royce and Associates, the Porter residence was an example of the contemporary architecture popular in Upper Arlington during the 1950s. Designs in this era exploited landscape features and molded the house shape to that of the contour of the land—a far cry from the formal styles found in the original Thompson brothers development. (Courtesy of the Upper Arlington Historical Society.)

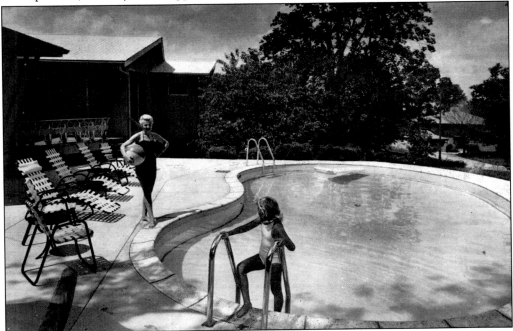

POOLSIDE, PORTER RESIDENCE. A feature of the Porter residence was the addition of an in-ground swimming pool, an example of the way life in Upper Arlington was changing for those who could afford such a luxury. (Courtesy of the Upper Arlington Historical Society.)

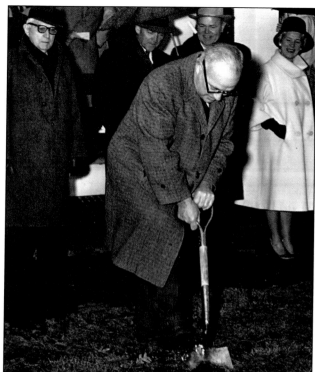

THE FIRST SHOVEL. In 1961, the James T. Miller mansion and grounds were sold for the construction of First Community Village, a senior citizen living complex. Mayor Warren C. Armstrong turned the first shovel of dirt on February 18, 1962, while, from left to right, Edward Howard, Dr. Roy Burkhart, Roy Tuggle, and Mary Moss look on. (Courtesy of Ann Armstrong Knodt.)

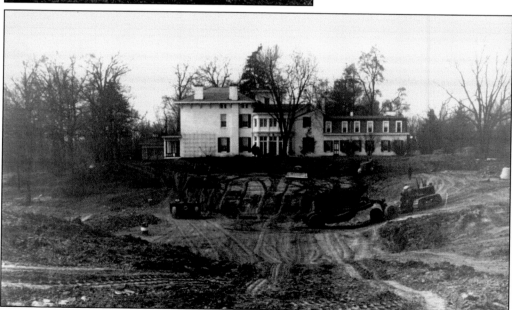

END AND BEGINNING, 1962. Construction began on First Community Village in the late winter of 1962, with the grading of the Miller property in preparation for construction. Once manorlike in its command over the land around it, the historic James T. Miller residence stands a silent sentinel over the progress that spelled its eventual demise in January 1975 when the house was razed. (Courtesy of the Upper Arlington Historical Society.)

SCHOEDINGER FAMILY, 1953. Standing in front of their Guilford Road home is the family of John and Juliet Schoedinger. Jay Schoedinger kneels in front of the family. From left to right are his mother, Juliet; his brother Steven; his father, John; and his brother David. (Courtesy of the Schoedinger family.)

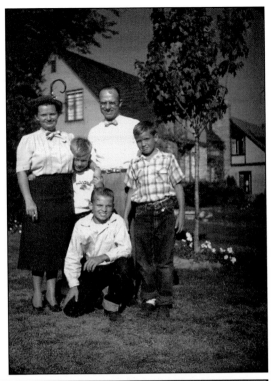

SCHOEDINGER FUNERAL HOME. In 1961, the Schoedinger family opened the first funeral home in Upper Arlington. Initially neighbors immediately adjacent to Kingsdale were opposed to the location of the business, fearing increased traffic from calling hours and services. However, those concerns quickly faded, and the business quickly earned its place within the Upper Arlington community. (Courtesy of the Schoedinger family.)

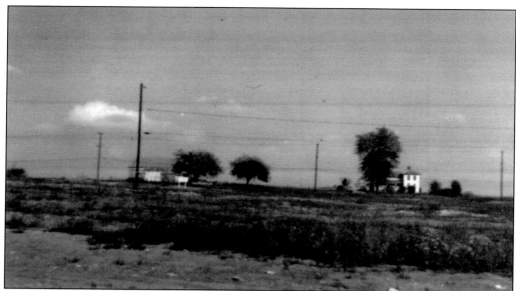

BECKETT-REED-SALZGABER FARM, ABOUT 1965. As late as the mid-1960s, land in what is now Upper Arlington remained under cultivation. Built before the Civil War by the Beckett family and occupied later by the Reed and Salzgaber families, this farm once stood northeast of the intersection of what are now McCoy and Reed Roads. Shortly after this image was taken, the farmstead was razed and the acreage sold for home sites. (Courtesy of the Upper Arlington Historical Society, Anna Marie Davidson Drake Collection.)

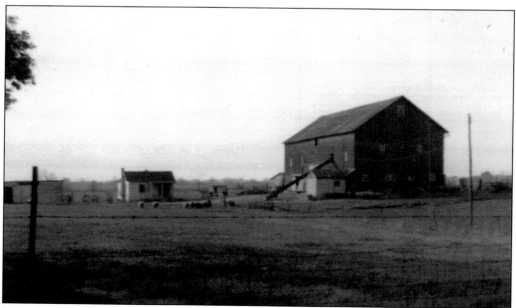

LANE BARN AND TENANT HOUSE, 1963. This barn and small tenant house once stood at 4607 Reed Road at the southwest corner of Reed and Henderson Roads. The barn and the house were burned in 1965 to make way for the Rinks Shopping Center, now known as Arlington Square. (Courtesy of the Upper Arlington Historical Society, Anna Marie Davidson Drake Collection.)

HENDERSON FARM, 1965. Once located on the northwest corner of Reed and Henderson Roads just outside of the Upper Arlington northern boundary was one of the Henderson family farmsteads. Like the Lane property across the road, the Henderson farm and residence were burned in 1965 in preparation for Northwest Shopping Center. (Courtesy of the Upper Arlington Historical Society, Anna Marie Davidson Drake Collection.)

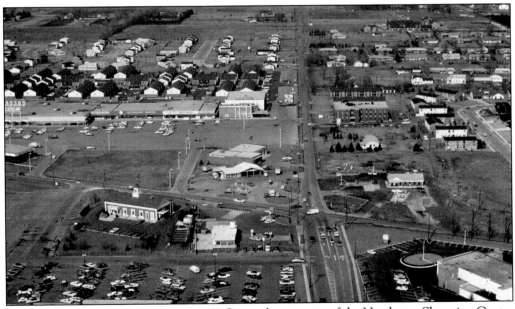

NORTHWEST SHOPPING CENTER, 1970. Original occupants of the Northwest Shopping Center included Big Bear, Buckeye Mart discount store, Kroger supermarket, and Lowes movie theater. In the 1970s, Lazarus department stores took over the Buckeye Mart space and introduced its "Capri Store" concept of value-priced items. It is interesting to note that Henderson Road is a two-lane road in this image. (Courtesy of the City of Upper Arlington.)

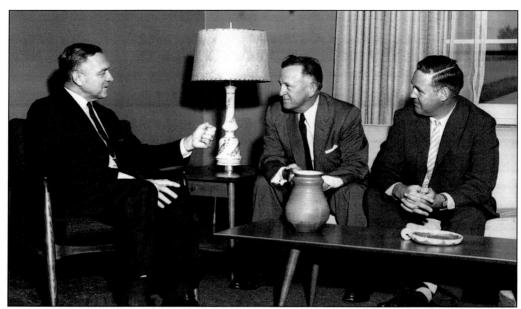

THERE IS AN ANSWER. Upper Arlington residents John Galbreath and Dr. Robert J. Murphy are interviewed by Dr. Roy A. Burkhart of First Community Church on "There's An Answer," which was hosted by Burkhart on WLW-C (later WCMH) television. All three men are on the Wall of Honor at the Upper Arlington Municipal Center. (Courtesy of the Galbreath family.)

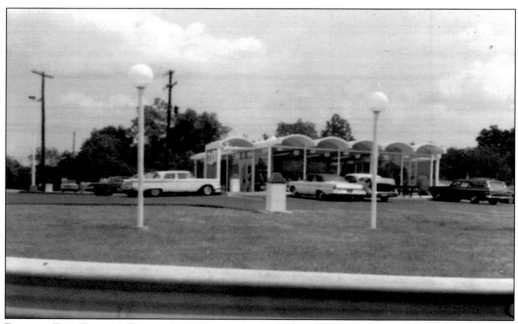

BURGER BOY FOOD-A-RAMA. Founded in 1961 by Milton Lustnauer Sr. and Roy Tuggle, Burger Boy Food-A-Rama Restaurant (BBF) at Riverside Drive and Fishinger Road opened in around 1964. BBFs were common sites throughout Ohio in the 1960s. The chain was sold to Borden foods in 1969 and renamed Borden Burger. (Courtesy of Jean Parks Williams.)

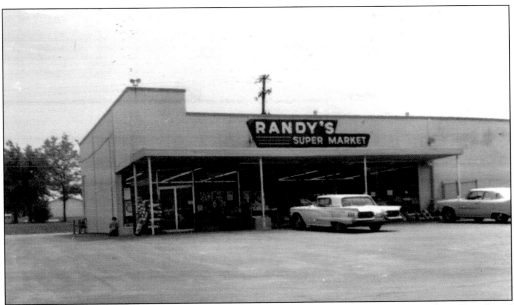

RANDY'S SUPER MARKET, 1964. Randy's Super Market, once located at Nottingham Road and Riverside Drive, is an example of the type of independent markets that dotted Upper Arlington from the 1940s through the 1970s. Randy's was also popular with visitors to Griggs Reservoir because it was located directly across the street from the park entrance. (Courtesy of Jean Parks Williams.)

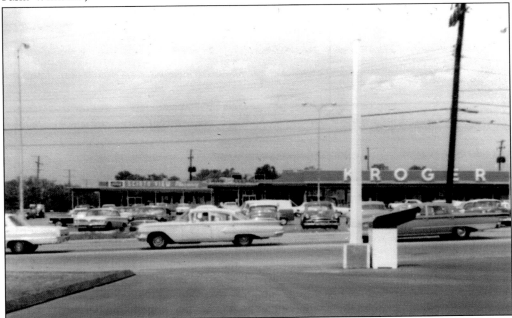

SCIOTOVIEW SHOPPING CENTER, 1964. Built in the late 1950s, Sciotoview Shopping Center was home to Sciotoview Pharmacy, Kroger supermarket, and Swan Cleaners when this picture was taken by Jean Parks Williams in 1964. In 2007, the owners of the center began the process of modernizing the facility into its current format. (Courtesy of Jean Parks Williams.)

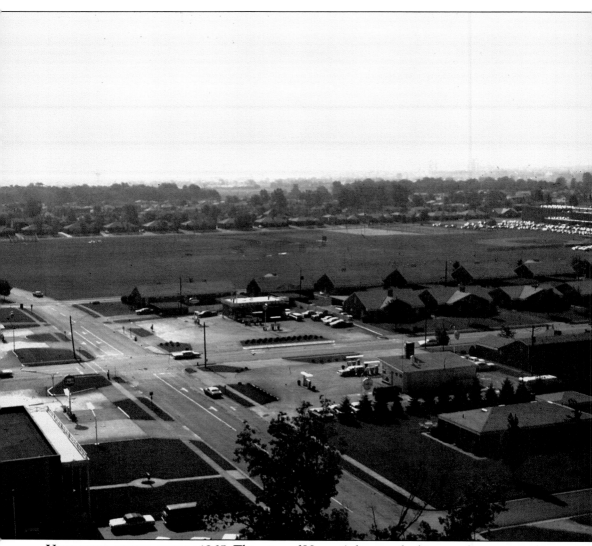

VIEW FROM ABOVE, ABOUT 1965. This view of Upper Arlington, looking southeast, was taken from the Kingsdale water tower. It provides a view that shows how quiet the area was in the early 1960s as well as the grounds of the new Upper Arlington High School that opened in 1956. The image is also notable for what did not exist yet—the high school stadium. (Courtesy of the City of Upper Arlington.)

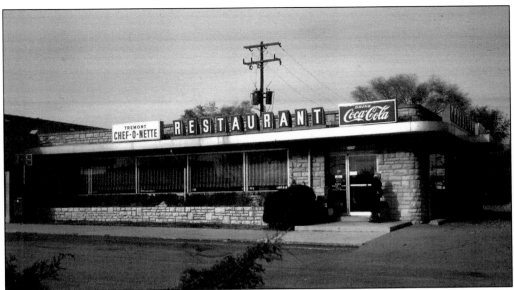

THE ONE AND ONLY, TREMONT CHEF-O-NETTE, ABOUT 1975. Delighting young and old alike since 1955 is the Tremont Chef-O-Nette. Started by Bill McKinley, the restaurant is now owned and operated by Harlan Howard. It still offers the only authentic counter service in northwest Columbus as well as the best classic comfort food in Upper Arlington. The menu still includes crinkle-cut french fries, hamburgers, and the daily chef's special. (Courtesy of the City of Upper Arlington.)

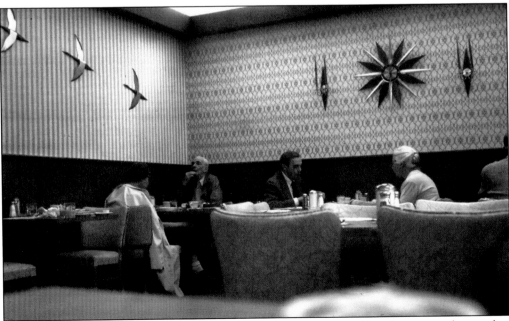

BACK DINING ROOM, CHEF-O-NETTE. In addition to counter and booth service, the timeless dining room at the Tremont Chef-O-Nette offers a quieter, classic atmosphere. Just watch for the pink neon sign that says "Dining Room Open." (Courtesy of the City of Upper Arlington.)

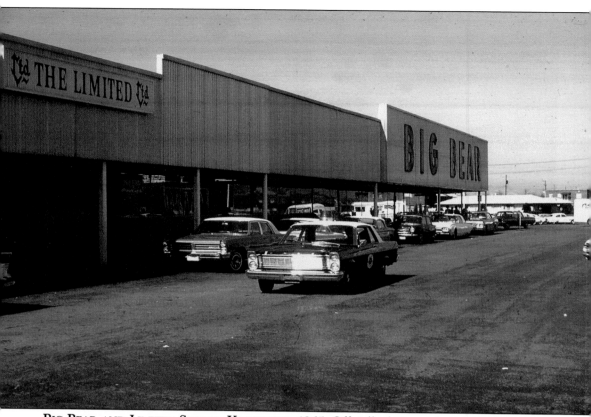

BIG BEAR AND LIMITED STORES, KINGSDALE, 1965. Officially designated store number 29, Big Bear supermarket's first Kingsdale location was billed as central Ohio's largest, most modern grocery store when it opened in 1958. Reconfigured in the early 1980s when the shopping center was renovated, the store was relocated in the 1990s when its new building (currently occupied by Giant Eagle) was completed. The chain was founded in Columbus in 1933 by Wayne Brown and was closed in 2004. Also captured in this image is the only known picture of the first Limited store opened by Les Wexner in its original location at Kingsdale. Wexner opened the store in 1963, focusing on clothing for young women. The success of the Limited has spawned a multi-million dollar fashion business, Limited Brands. (Courtesy of the City of Upper Arlington.)

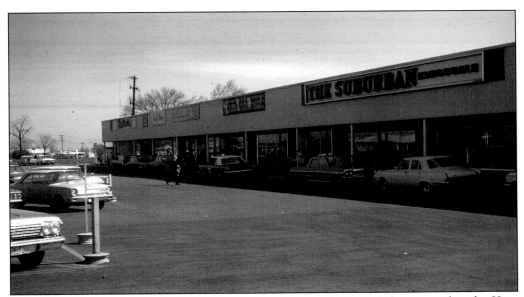

KINGSDALE SHOPPING CENTER, 1965. Named in honor of Upper Arlington cofounder King Thompson, Kingsdale was also developed by the King Thompson Company. The stores populating Kingsdale Shopping Center's west-facing section (looking north toward Tremont Road) in 1965, included Easton Shoes, Youth Land, and the Suburban, Kingsdale. When this picture was taken, Lazarus had yet to begin construction of its store at the end of this block of shops. (Courtesy of the City of Upper Arlington.)

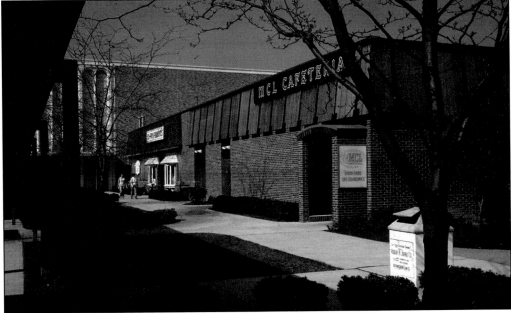

MCL AT KINGSDALE. Despite the success of the enclosed Lane Avenue Mall in the 1980s, Kingsdale Shopping Center's owners decided to keep its outdoor-mall configuration for its inner courtyard. One tenant that always seems to be popular is the MCL Cafeteria. (Courtesy of the City of Upper Arlington.)

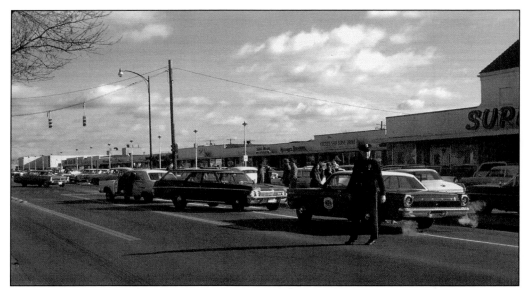

ACCIDENT ON LANE AVENUE, 1965. The popularity of the Lane Shopping Center in the 1960s and the amount of traffic carried on Lane Avenue resulted in occasional accidents in front of the shopping center. This view is one of the few available that shows the center in its original configuration. A Big Bear store was located at the far east end of the shopping center as was G. C. Murphy and Company, a dime store, Lombard's Home Makers store, Isaly's Dairy, and Coulter's Self Serve Pharmacy. (Courtesy of the City of Upper Arlington.)

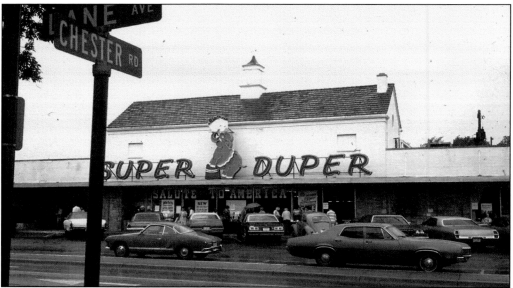

SUPER DUPER, LANE SHOPPING CENTER. Located on the western edge of Lane Shopping Center, the Super Duper supermarket occupied a building originally built as Lane Theater. Shoppers who planned their marketing carefully could count on gravity and the slightly sloped theater floor to help move their carts along as they shopped. This structure was razed in the late 1970s for the food court building of the renamed Lane Avenue Mall. (Courtesy of the City of Upper Arlington.)

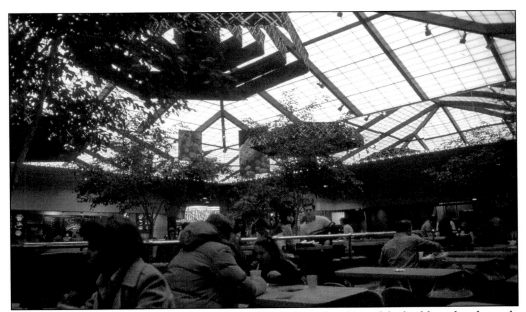

LANE AVENUE MALL FOOD COURT, ABOUT 1980. Taking the place of the building that formerly housed the Super Duper grocery store was the Food Court at Lane Avenue Mall. The food court was the first of its kind in northwest Columbus. Closed in the late 1990s, the structure was converted during the 2004 renovation of the former mall, which now operates under the name Shops on Lane Avenue. (Courtesy of the City of Upper Arlington.)

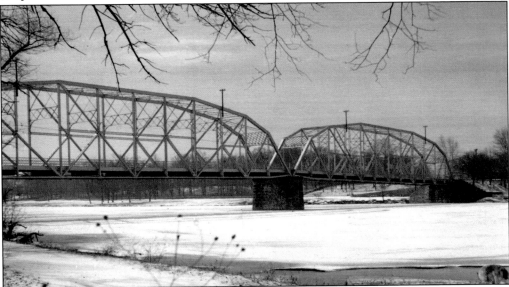

FISHINGER ROAD BRIDGE, 1940S. Built in 1906, the double through truss steel bridge that spanned the Scioto River plain and Griggs Reservoir at Fishinger Road served the purpose of joining Stony Point on the east bank of the river plain with the west bank and Dublin Road. Though plans to replace the structure were discussed as far back as the 1950s, the structure served into the 1980s, when it was replaced by the current four-lane span. (Courtesy of Ann Armstrong Knodt.)

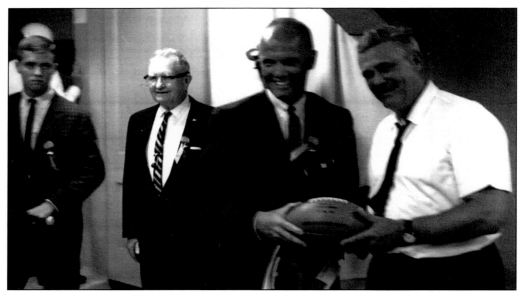

WOODY HAYES. Woody Hayes (right) and John Glenn (second from right) were captured in this rare unrehearsed moment during a meeting between the two Ohio celebrities in the late 1960s. Both men were the antithesis of pretension. Hayes was a firm believer in "paying forward" for the good of all human-kind. The Ohio State University invited Hayes to deliver the winter quarter 1986 commencement, and he used this theme in his speech. (Courtesy of the Ohio State University.)

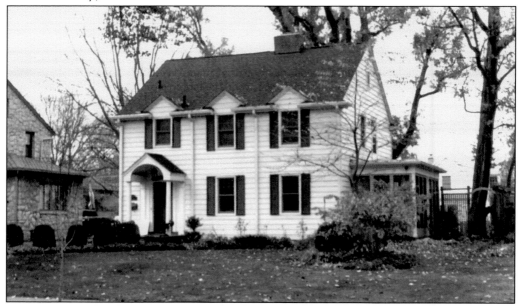

FORMER HAYES RESIDENCE. Hayes and his wife, Anne, lived in this house on Cardiff Road, an example of the type of Colonial Revival homes that were built from the mid-1920s to the 1960s. Such houses were heavily influenced by the small-homes movement of the 1920s, which helped to bring individuality to quality built, affordable homes for families without need of household staff for upkeep. (Courtesy of Stuart J. Koblentz.)

Six

CIVIC AFFAIRS

As more houses were built and more residents moved into the new development, the community saw a need for more structure and governance. On March 20, 1918, the village was incorporated, and an election was held three months later. A 10-member village council was elected with James T. Miller becoming the first mayor.

Also elected was a charter commission to draft the Charter of the Village of Upper Arlington, which became effective on March 29, 1919. This charter was in compliance with the general law governing municipalities at that time but was adapted to the community. It was forward thinking enough to include full suffrage for women more than a year before women won the right to vote nationally.

When the village was granted city status in 1941 with a rapidly growing population, it became evident that changes in its administrative structure were needed. After much study, the citizens elected a form of government with a seven-member city council elected at large on a non-partisan basis and a professional city manager to carry out the policies of that elected board. This structure is still in place today.

The first municipal services building was completed in 1930 and housed all city services. In 1972, the new municipal service center was completed, which is still in use. The original municipal services building is now fire station No. 71.

With the development of a fine community comes an expectation for superior services to support the citizens. Although city divisions have grown with the population, they continue to strive to provide the highest quality of professional service for the residents.

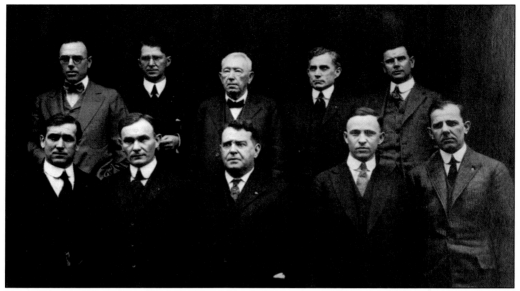

First Village Council, about 1918. From left to right are (first row) William F. Kern, Paul G. Spence, J. E. Harris, E. J. Crane, and J. J. Morgan; (second row) Warren A. Armstrong, Frank Rogers, Mayor James T. Miller, Edward D. Howard, and Ben Thompson. (Courtesy of the Upper Arlington Historical Society.)

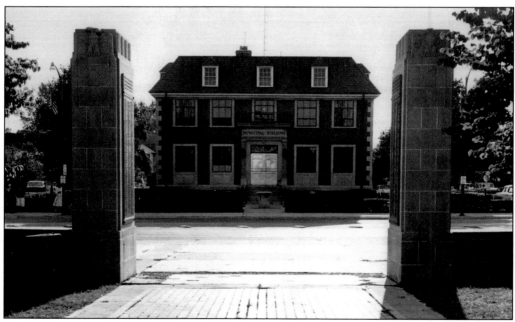

First Municipal Services Center. The fire and police stations and municipal offices were all housed in this building on Arlington Avenue for over 40 years. Built in 1930, the lovely Federal Revival–style building with its big, brass doors is still in use as fire station No. 71. This photograph was shot between pillars of the war memorial on the Mallway. (Courtesy of the City of Upper Arlington.)

OLD COUNCIL CHAMBERS. This wood-paneled room on the third floor of the first municipal services building was the venue for council meetings. It is now the meeting room and archives for the Upper Arlington Historical Society. (Courtesy of the City of Upper Arlington.)

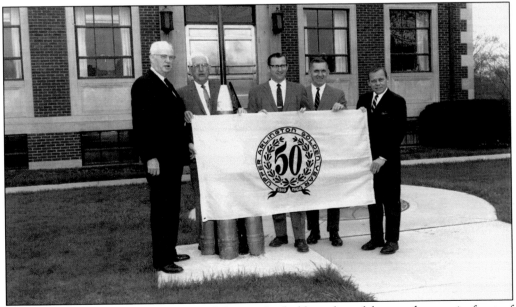

GOLDEN ANNIVERSARY, 1968. From left to right, holding the celebratory banner in front of the then municipal services center, are honorary cochairmen of the Golden Year Celebration Committee, Sen. John Bricker and Dr. Link Murphy; acting city manager Hal Hyrne; Upper Arlington civic association president Leonard Zane; and Mayor Richard F. Broughton. (Courtesy of the Upper Arlington Historical Society.).

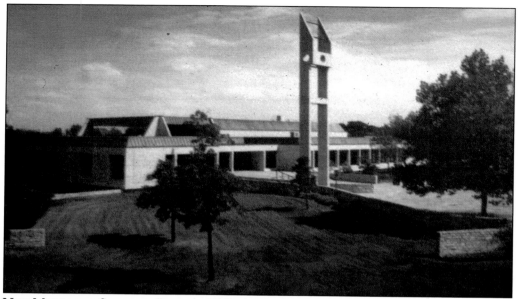

NEW MUNICIPAL SERVICES CENTER, 1972. A growing community needed a larger government building. In 1972, a new municipal services center was built at 3600 Tremont Road, which is still in use today. In 1974, the building received the City Beautiful Award from the Columbus Convention and Visitor's Bureau. (Courtesy of the City of Upper Arlington.)

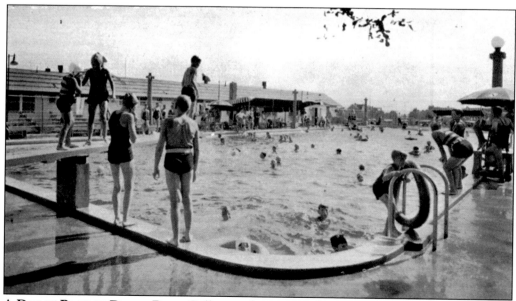

A DAY OF PLAY AT DEVON POOL. Still a popular summer destination, the Devon pool was built between the temporary school to the south and the 1924 Upper Arlington School building to its north. Nighttime illumination was provided by the old-style streetlamps. At the time, the pools were the responsibility of the school district, but they have since been transferred to the city. (Courtesy of the Upper Arlington Historical Society.)

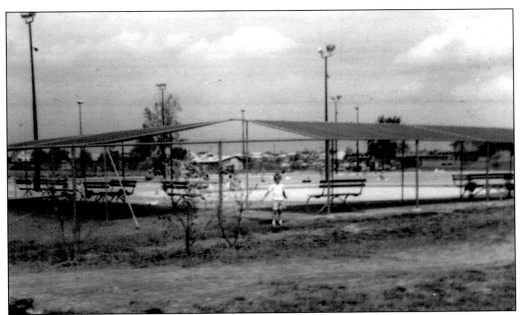

HASTINGS POOL. Hastings swimming pool was the third pool built in Upper Arlington and accommodated the children in the northern part of the city. In 2005, this pool was replaced with Reed Road Water Park. (Courtesy of Jean Parks Williams.)

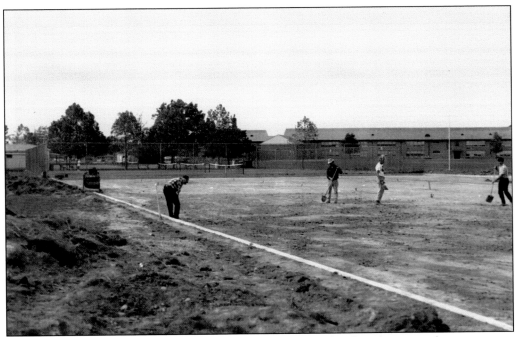

TENNIS COURTS AT NORTHAM PARK. Tennis was so popular that the original tennis courts at Northam Park were always crowded. In the mid-1970s four more courts were added to accommodate the popular sport. (Courtesy of the City of Upper Arlington.)

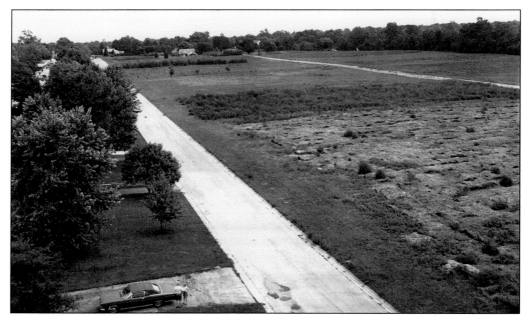

WHAT AN IMPROVEMENT A PARK MAKES. This area was developed into Fancyburg Park. There were houses on Swansea Road with a view of the empty lot, which became tennis courts, a shelter house, playground equipment, and playing fields. (Courtesy of the City of Upper Arlington.)

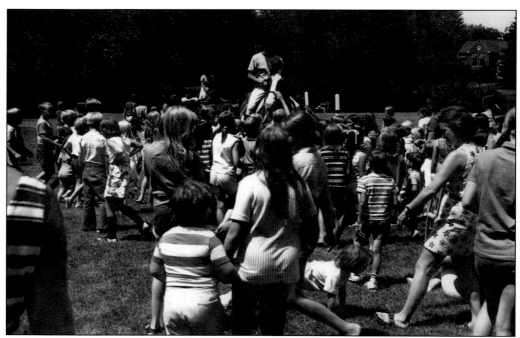

HORSE DAY AT SUMMER CAMP, 1971. Neighborhood children gather for the popular horsemanship demonstration at the summer playground program, sponsored by Upper Arlington Parks and Recreation. (Courtesy of the City of Upper Arlington.)

LABOR DAY ARTS FESTIVAL. This annual event was put together by neighbors and was first held in 1966 at Miller Park. In 1983, it was hosted by the Cultural Arts Commission and held on the grounds of the municipal services center. When it outgrew that venue in 1986, it was moved to Northam Park, where it continues to be held today. (Courtesy of the City of Upper Arlington.)

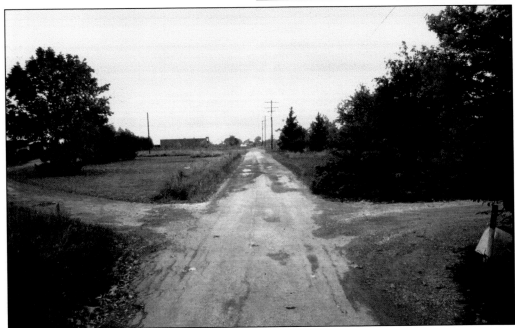

OUT IN THE COUNTRY, 1972. Coach Road in the northern section of Upper Arlington was nothing but dirt in the 1970s before some of the roads were paved. Many of its early structures are now being replaced with upscale homes. (Courtesy of the City of Upper Arlington.)

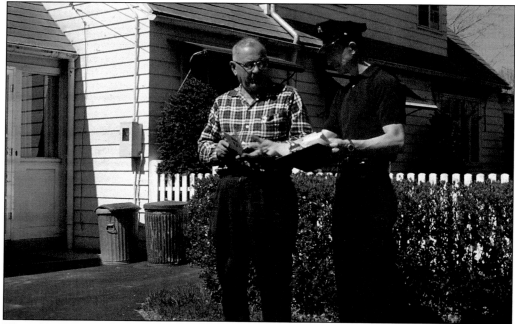

HOME INSPECTION. Firefighter John Haney is discussing a home inspection with a resident. Haney later served as fire chief from 1982 until his retirement in 1991. (Courtesy of the City of Upper Arlington.)

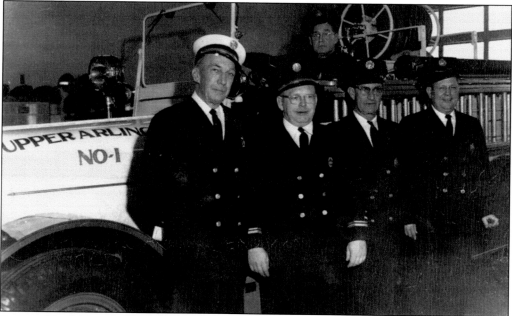

ENGINE NO. 1. Proud of the community's first fire truck, from left to right, are Fire Chief William Montgomery, Capt. Sam Martin, firefighter J. King Thompson, and firefighter Karl Rinehart. Sitting in the truck is firefighter Eddie Baker. The fire division is currently restoring the 1930 Seagrave engine back to its original elegance. (Courtesy of the City of Upper Arlington.)

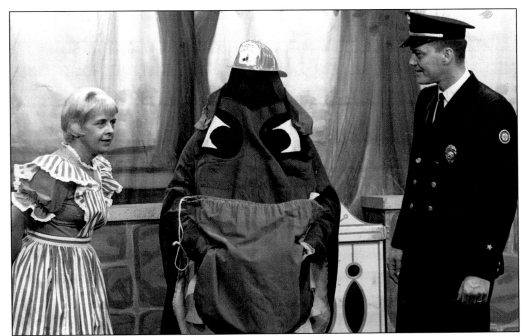

MISS LUCI MEETS UPPER ARLINGTON FIRE INSPECTOR. To teach young children about fire safety, fire inspector Fred Long visited Luci's Toyshop and talked to Luci VanLeeuwen and Dragon about not playing with matches and knowing how to escape their homes in case of a fire. (Courtesy of the City of Upper Arlington.)

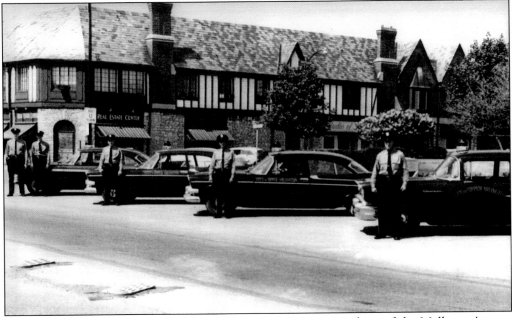

THE LINE UP, 1958. The police force shows off their cruisers in front of the Mallway. As part of the 50th anniversary celebration of the police force, officers had the photograph retaken with their current cruisers. (Courtesy of the City of Upper Arlington.)

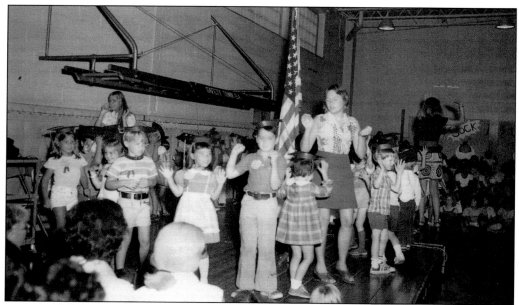

SAFETY TOWN HOKEY POKEY. Safety Town, a two-week summer program for preschool children sponsored by the police division, has been an important part of growing up for Upper Arlington children since 1971. It teaches pedestrian and traffic safety, fire prevention, and personal safety. Much has changed over the years, but graduation still includes dancing the ubiquitous Hokey Pokey. (Courtesy of the City of Upper Arlington.)

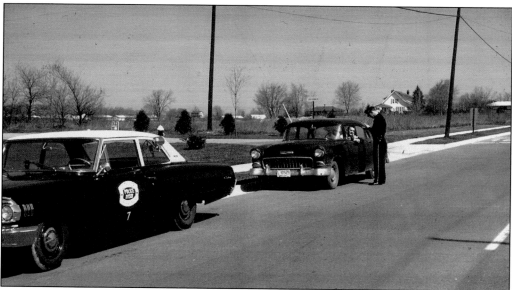

LICENSE AND REGISTRATION, PLEASE. Besides providing for the general safety of the community through enforcement of laws, the Upper Arlington Police also patrol the roadways to ensure that traffic laws are obeyed and that vehicles are operated in a safe manner by licensed drivers. In this 1965 public relations image, an Upper Arlington police officer stops a motorist along the southbound lane of Reed Road. (Courtesy of the City of Upper Arlington.)

Seven

EDUCATION

The nucleus of a community is its school system. Before Upper Arlington, country schools educated children in southern Perry Township. They were Woody Bower on Henderson Road, Swamp College on McCoy Road, Stony Point School at Fishinger Road and Riverside Drive, and Fairview School at Lane Avenue and Tremont Road. In 1920 Stony Point, Swamp College, and Fairview Schools were consolidated into a modern building on Fishinger Road named South Perry Township School.

The Thompson brothers recognized that educating the next generation of citizens was tied to the future well-being of a community and felt responsible for the education of the young children moving into their new development. In 1917, a school began in the basement playroom of King Thompson's home, with 13 children and one beloved teacher. The next year, a school was built on the southeast corner of Tremont Road and Arlington Avenue out of wood left from Camp Willis. The student population quickly outgrew that facility, and the next summer, the building was moved to Waltham Road and rooms were added. The first permanent school building, which was built in 1924, was designed by Howard Dwight Smith. Enlarged in 1926, this building housed all the students until 1939 and then served as Upper Arlington High School until 1956. It is still in use as Jones Middle School.

With the annexation of additional land and the post–World War II baby boom generation entering school, four new schools were built in neighborhoods north of Lane Avenue in the 1950s. Once the baby boomers completed their schooling, the district adjusted by closing some schools.

South Perry Township School was absorbed into the Upper Arlington system, and that building now serves as the lower school for Wellington School. Parochial schools were added in the 1940s and 1950s with St. Agatha and St. Andrew.

Today the school system continues to win recognition on a state and national level. It is known for its innovative and superior teaching as well as success in sports, music, and other extracurricular programs. People continue to move into the community so their children can have the advantage of an Upper Arlington education.

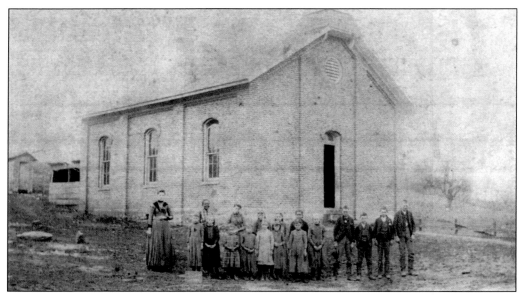

STONY POINT SCHOOL, ABOUT 1889. One of the early country schools that taught the children of farmers on the land that later became Upper Arlington, Stony Point School was located on the south side of Fishinger Road at what is now Riverside Drive. Pictured here are Ethel Richards, Eva McCoy, Edgar McCoy, Harvey McCoy, Jess Delashmutt, Johnny McCoy, Nancy McCoy, and Mae Richards. (Courtesy of the Upper Arlington Historical Society, Anna Marie Davidson Drake Collection.)

MARY BOYER WITH STUDENTS, ABOUT 1917. This private school with 13 pupils in the first three grades was held for one year in the basement playroom of the King Thompson home. Teacher Mary Boyer's philosophy is still a cornerstone of Upper Arlington schools today, "Education consists in training the child to cope with its environment through life and to serve society." Older students attended school in Grandview. Pictured here is Boyer with students Warren C. Armstrong and Carol Arnos. (Courtesy of Ann Armstrong Knodt.)

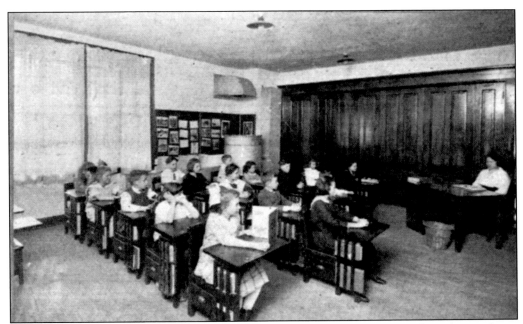

BARRACKS SCHOOL BUILDING, 1918. The Barracks School originally stood on the southeast corner of Arlington Avenue and Tremont Road. Local architect Edgar Outcalt designed the building that was built of material left over from Camp Willis. It opened in October 1918 with three teachers and 52 students in grades one through nine. The building had electricity and the most modern heating and plumbing available at the time. (Courtesy of the Upper Arlington Historical Society.)

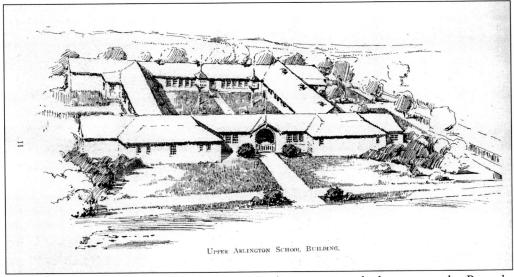

UPPER ARLINGTON SCHOOL BUILDING.

WALTHAM ROAD SCHOOL, 1919. In one year, the community had outgrown the Barracks School, so in the summer of 1919, the schoolhouse was rolled on logs up Arlington Avenue to Waltham Road. More rooms, centered on an open courtyard, were added to accommodate the growing school population. This sketch was printed in the September 1919 *Norwester* magazine. (Courtesy of the Upper Arlington Historical Society.)

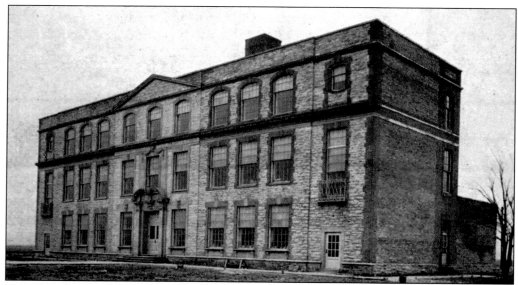

THE NEW SCHOOL BUILT IN 1924. The first permanent school building for the new community housed the first six grades while the upper grades stayed in the old school building next door. Wings were added to both ends, and two years later, it was large enough to accommodate the entire school population. Later it served as the high school, but once the present high school was built on Ridgeview Road, this building became Jones Junior High and then Jones Middle School. (Courtesy of the Upper Arlington Historical Society.)

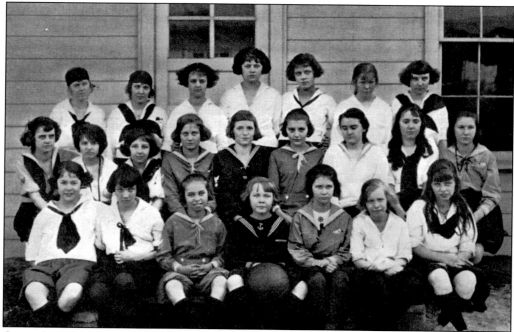

GIRLS CONSOLIDATED BASKETBALL TEAMS, 1922. There were several teams of girls' basketball at the Waltham Road School, as evidenced by the different uniforms worn by these team members. (Courtesy of the Upper Arlington Historical Society.)

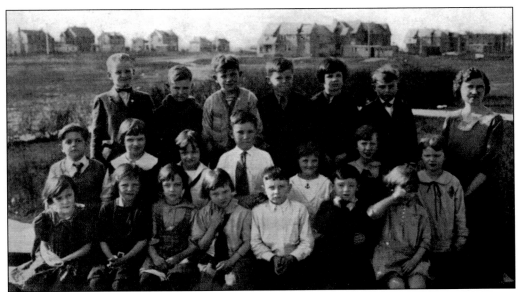

SECOND GRADE, 1924. Fidgety children try to sit still for their class picture. Left to right are (first row) J. Young, M. Miller, B. Pape, H. Pfening, R. Knoderer, J. Dauben, and D. Young; (second row) F. Moyer, E. Avery, E. Martin, R. Calland, E. Miller, G. H. Schneider, and B. W. Crane; (third row) R. Nosker, P. Huddleson, J. Reinheimer, E. Morris, M. K. Denbow, J. H. Schwartz, and teacher Pearl M. Casiday. (Courtesy of Esther Miller.)

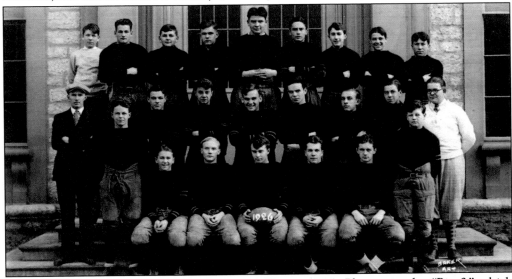

BUDDING GOLDEN BEARS, FIRST FOOTBALL TEAM, 1926. Playing in the "Big 3," which consisted of schools from Grandview, Bexley, and Upper Arlington, members of the football squad are, from left to right, (first row) Nash Kelly, Bob Kelly, Sandy Francisco, team captain Abie Jones, Stu McFarland, Bill Miller, and John Wuichet; (second row) coach J. M. Baugh, Warren Armstrong, Fritz Radebaugh, Chet Mirick, Vince Parrish, Jack Miller, Dallas Head, and manager Jack Bornhauser; (third row) manager Bob Barnes, Elson Parker, Wayne Geissinger, Carl Shumaker, Frank Sayers, Chuck Lewis, Pierce Denman, Tim Armstrong, and Bill Kern. (Courtesy of Upper Arlington Education Foundation.)

AVIATION ARLINGTON STYLE, 1932. Jack Durrant and Joe Mason, both 17, built two of these airplanes in the south attic of the old high school with the support of then-superintendent J. W. Jones. After numerous successful flights, this glider cracked up on July 4, 1932. From left to right are Jack Durrant, Gene Durrant, Bob Mason, Pat Jones, Lloyd Osborn, and Joe Mason. (Courtesy of Upper Arlington Historical Society.)

PRACTICE IN MILLER PARK, 1939. Members of the Upper Arlington seventh-grade football team practiced in Miller Park for this image. Note that the ground behind the players was painted out for its original publication. From left to right are (first row) Jack Sampson, John Gerlach, Ralph Khourie, Jim Ebright, George Eckelberry, Dick Odebrecht, and Bill Meade; (second row) Bob Skeele, Fred Morrison, John Rarey, and Bill Khourie. (Courtesy of the Upper Arlington Historical Society.)

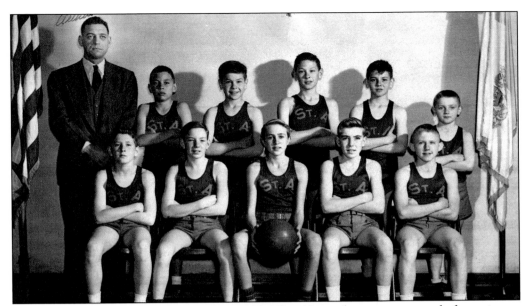

St. Agatha Basketball Team, 1947–1948. This 10-member team was ready for action to represent the newly opened St. Agatha Catholic School. The elementary school opened in 1941 with 46 children in the first six grades. As early as the 1930s, the Columbus diocese understood that the growth of Upper Arlington required a parish school to meet the demand of families moving to the area. (Courtesy of St. Agatha School.)

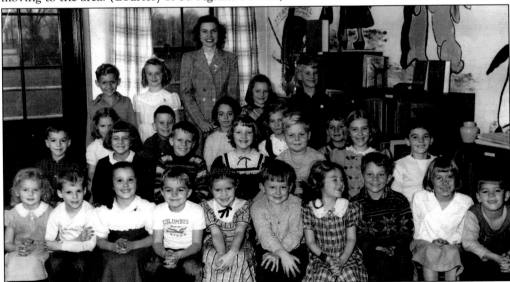

Miss Gilliland's Second-Grade Class at Barrington, 1947–1948. This photograph was taken at a time when all girls wore dresses to school. From left to right are (first row) Sally Grimes, Larry Minor, Margie Flory, Bob Neal, Georgie Smith, Peter Clausen, Beverly Manos, Dick Cottingham, Mary Beth Fontana, and ? Sain; (second row) Bob Fultz, Jean ?, David Dicke, Annette Zelkoff, David Tuller, Mary Ellen Long, and Ed ?; (third row) Carol Youmans, Beau Gehring, Susan Lund, Sandra Henry, and Steve Colby; (fourth row) Jerry Sarver, Linda Snashall, Miss Gilliland, Sandy McIntire, and Peter McCellend. (Courtesy of Linda Snashall Cummins.)

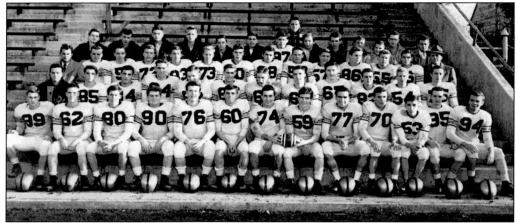

THE RECORD WILL STAND, 1950. The Golden Bear varsity football team enjoyed a perfect season, becoming Columbus Buckeye League Champions. From left to right are (first row) Hudson, Cammarn, Miller, McEntee, Fenner, Edwards, Hamilton, Weigel, Goodsell, Lamb, Trautman, Gates, and Cott; (second row) Kish, Rosenow, Baker, Johnson, Karow, Pennell, Holub, Hadley, Hamiel, Tippett, Schick, and Ireland; (third row) coach Perry, Gehlbach, Dameron, Petrie, Barneson, Matheson, VanDeventer, Yates, Minton, Rardon, Root, VanFossen, Stroud, Thomas; (fourth row) Gilbert, Lorig, Amos, Sandbo, Gilbert, Sharer, Pataky, Nofer, Gutherie, Arnold, Boyd, Whipps, Bright, and Rowedda. (Courtesy of the Upper Arlington Historical Society.)

TREMONT ROAD ELEMENTARY SCHOOL DEDICATION, 1952. This drawing was on the cover of the program for the dedication ceremony at Tremont Road Elementary School. With the baby boom beginning and more people moving into Upper Arlington, there was a need for a second elementary school to accommodate children north of Lane Avenue. A bond issue was passed by the voters the following week, and an addition was opened the next year. (Courtesy of Tremont Elementary School.)

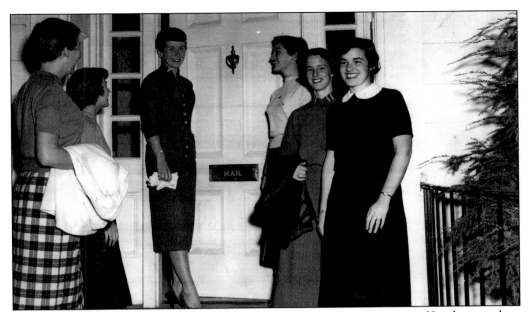

CHARMED, I AM SURE, 1956. Former Charm Board member Ann Armstrong Knodt remembers being on the Charm Board as something very special. Members were selected by faculty and helped to set the style pace for female students at Upper Arlington High School. In addition to hosting an annual fashion show at the House of Fashion, the Charm Board also presented tips on the rules of dating. (Courtesy of Ann Armstrong Knodt.)

EAGERLY AWAITING THE FIRST DAY OF SCHOOL, 1964. This Shrewsbury Road group of children played together all summer long, and here they are off to Wickliffe School to start a new year. From left to right are (first row) Robin Wagner, Mark Baker, Karen Gilbert, Sandy Tice, and Debby Baker; (second row) Dickie Wagner, Jeff Gilbert, Sally Gilbert, Barbara Tice, and Cindy ?. (Courtesy of Jean Parks Williams.)

HASTINGS JUNIOR HIGH, NINTH-GRADE GLEE CLUB, 1964–1965. These girls are taking time out from singing to pose for a picture. From left to right are (first row) Robin Lawrence, Dana Vittur, KiKi Patterson, Judy Glaze, Nancy Wolfe, Cathy Pferle, and Jean Balser; (second row) Patty Stevens, Linda Stieble, Cassie Gadnai, Shelly Heselton, Shelia Schwartz, Sue Cochran, Dolly Hitesman, and Michelle Mosel; (third row) Marcia Springston, Kathy Bland, Bonnie Peterson, Jane Gall, Diane Cooper, Jan Boyer, Deb Murphy, and Maureen Turk. (Courtesy of the Upper Arlington Education Foundation.)

TO BE OR NOT TO BE WAS NEVER THE QUESTION. A generation of sixth graders had the wonderful experience of learning "to project their voices, to enunciate, to support their fellow actors, to hold character and to be enthuuuuusiastic," with Mrs. Reider. For 35 years, Reider conducted two-week Shakespeare immersion classes to 24,000 sixth graders in central Ohio. Participants learned about the life and times of the bard, memorized their lines, and wore Elizabethan finery. (Courtesy of Dusky Reider.)

Eight

CLUBS AND
ORGANIZATIONS

From gun clubs to golf clubs and sororities to scouts, Upper Arlington has always boasted an active community involved in many leisure-time diversions. The most notable club to frequent the land before the founding of Upper Arlington was that of the Columbus Gun Club, which built its clubhouse near what is now the intersection of Arlington and West Fifth Avenues. Target and trapshooting were offshoots of hunting. The gun club was the scene of practice rounds and tournaments in its day.

In the early years, new residents joined established organizations in Grandview Heights and Marble Cliff, but as the community grew, clubs and organizations were organized by local residents. Some of them are chapters of national organizations, and some are local to the community. One of the most active groups in the community has been the Upper Arlington Civic Association, which sponsors the annual Fourth of July parade that is covered in chapter 9 of this book.

The Miller house was the scene of many parties and much entertainment of the community. The Thompson brothers also gave parties and opened their houses for community events. Soon after the Thompson brothers started developing their country club community, local men saw a need for a golf course, and the private Scioto Country Club was started. A corporation was formed, land was bought from the Miller family in March 1915, and the club opened in 1917 with 310 members. Provisions were also made for the Upper Arlington Golf Club, which sat west of Arlington Avenue. This community golf course had its small clubhouse north of Waltham Road, but it closed in 1934.

This collection of photographs is a small review of some of the clubs and organizations and does not show the breadth of sports, service, and social opportunities available to residents.

COLUMBUS GUN CLUB. Located on Fifth Avenue near what is now Arlington Avenue was the clubhouse and grounds of the Columbus Gun Club. As sport and social outlets, gun clubs in the years before World War I provided a popular gathering place for the well-to-do. The clubhouse was built in 1905 and designed by noted Columbus architect J. Upton Gribbon. Lon Fisher served as the club manager and lived with his family on the second floor of the building. Following the sale of the Miller farmland to the Upper Arlington Company, the clubhouse was vacated and the club moved eastward away from the development area. The Warren Armstrong family lived on the second floor of the structure while awaiting completion of their Roxbury Road residence. Ultimately the structure was razed, and the land was redeveloped for building lots. Homeowners in the vicinity of the land near the shooting range have reported finding empty shell casings while digging in their gardens, which either date to the gun club or the Camp Willis eras. (Courtesy of Jean Parks Williams.)

COLUMBUS GUN CLUB MEMBERS. Lon Fisher (first row, left) poses with four unidentified members of the Columbus Gun Club in this image from about 1909. Fisher served as the manager and secretary of the club from 1908 to 1912. Later, he was the original owner of Fishers Bathing Beach at Buckeye Lake. (Courtesy of Jean Parks Williams.)

ANNIE OAKLEY. According to Jean Parks Williams, famed sharpshooter Annie Oakley, born Phoebe Ann Mosey (or Mozee), visited the Columbus Gun Club around 1908. She was captured in this image looking relaxed, out of costume, with her trademark long hair up, and notably without a shotgun. Around her waist, the native of Darke County wears a Native American beaded bag. (Courtesy of Jean Parks Williams.)

ONE-ARM SHOOTER. Photographed at the Columbus Gun Club, it is unknown who this gentleman is; however, his disability was apparently no match for his determination and skill. Those familiar with shotguns, such as the one in this image, will note that in addition to great upper-body strength, this marksman also demonstrates good balance to hold his weapon with such grace. (Courtesy of Jean Parks Williams.)

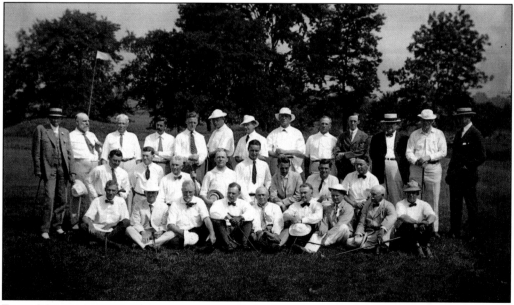

FIRST MEMBERS, 1917. The camera captured the first members of Scioto Country Club during a collective momentary pause in 1917. Scioto's membership included many of the men who had belonged to the Aladdin Country Club in Marble Cliff. Included in the group is Samuel Prescott Bush, grandfather of former president George H. W. Bush and great-grandfather of Pres. George W. Bush. (Courtesy of Scioto Country Club.)

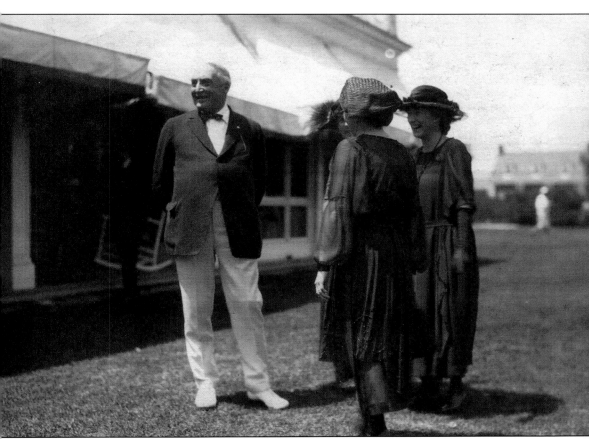

Sen. Warren G. Harding Visits Scioto Country Club. U.S. senator Warren G. Harding traveled to Scioto Country Club for its dedication. In this image, he is in the company of Jessie and Grace Miller. While in the U.S. Senate, Harding took up the sport of golf. Members of the press were quick to note that Harding's playing style was more an aerobic workout, consisting of hitting the ball and constantly moving (and playing through) than playing a game of patience and great skill. The 1920 presidential race pitted Harding against Gov. James Cox of Dayton. Both candidates were from Ohio, and both candidates were newspaper publishers—Cox owned and published the *Dayton Daily News* and Harding owned and published the *Marion Star*. In its 1920 recap of the presidential vote, the *Norwester* magazine reported that Upper Arlington voters resoundingly supported Harding, who beat Cox by a significant margin. (Courtesy of Esther Miller.)

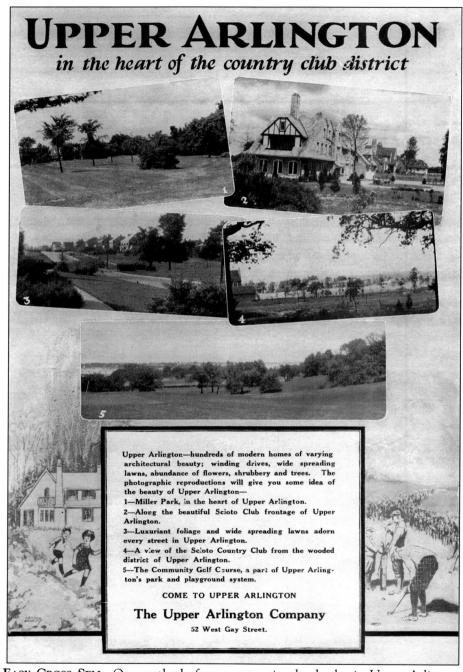

UPPER ARLINGTON
in the heart of the country club district

Upper Arlington—hundreds of modern homes of varying architectural beauty; winding drives, wide spreading lawns, abundance of flowers, shrubbery and trees. The photographic reproductions will give you some idea of the beauty of Upper Arlington—

1—Miller Park, in the heart of Upper Arlington.

2—Along the beautiful Scioto Club frontage of Upper Arlington.

3—Luxuriant foliage and wide spreading lawns adorn every street in Upper Arlington.

4—A view of the Scioto Country Club from the wooded district of Upper Arlington.

5—The Community Golf Course, a part of Upper Arlington's park and playground system.

COME TO UPPER ARLINGTON

The Upper Arlington Company

52 West Gay Street.

AN EASY CROSS SELL. One method of cross-promoting land sales in Upper Arlington was through advertising in sporting magazines. This 1930 advertisement features Miller Park (1); well-designed homes (2); appealing streetscapes (3); Scioto Country Club (4); and the Upper Arlington Golf Club (5), located off of Waltham Road west of Cambridge Boulevard. The Tremont Road home featured in illustration three was that of Upper Arlington's former mayor William Grieves. (Courtesy of Scioto Country Club.)

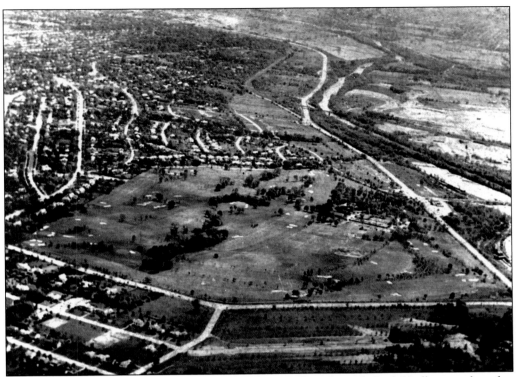

SCIOTO COUNTRY CLUB, 1945. In 1945, John Galbreath and Carl Hadley purchased a government-surplus airplane. One of the uses was for aerial photography. Not only does this image show the layout of Scioto Country Club at the time, but it also shows an unpaved Onandaga Road west of Asbury Road along the bottom of the image. (Courtesy of Carlyle Handley.)

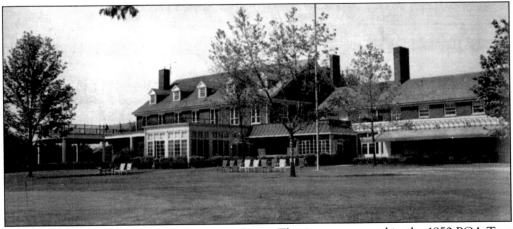

ORIGINAL CLUBHOUSE, SCIOTO COUNTRY CLUB. This image appeared in the 1950 PGA Tour program, and shows the original clubhouse at Scioto Country Club. The main two-section building burned in 1951 and was replaced by the current clubhouse. Lost in the fire were many of the historical records dating back to the club's establishment in 1917. (Courtesy of Scioto Country Club.)

Jack Nicklaus at 15. Raised in Upper Arlington, young Jack Nicklaus took up golf at the age of 10. By the time he was a teenager, he was a force to be reckoned with on the golf course. A graduate of Upper Arlington High School, his name became a household word after winning the 1962 U.S. Open. (Courtesy of the Upper Arlington Historical Society.)

JACK W. NICKLAUS

Insurance Planning Service

26 N. Grant Columbus, Ohio

Bus.—CA 8-2691 Home—HU 8-4422

A Little Career Insurance. In 1961, a young, forward-thinking Nicklaus insured his future by advertising his insurance business in the *Scioto Country Club Annual*. In 1962, Nicklaus won the U.S. Open, beating legend Arnold Palmer for the title, and setting in motion a legendary career away from insurance. (Courtesy of Scioto Country Club.)

SCIOTO COUNTRY CLUB YEARBOOK, 1959. One way the Scioto Country Club reviewed the year past was with the annual yearbook publication. The cover of the 1959 yearbook featured incoming country club president, James J. Butler, and his wife (left), as well as outgoing president, Frank Barnes, and his wife during the president's inaugural ball, which was said to be the social event of the season held at the club. (Courtesy of Scioto Country Club.)

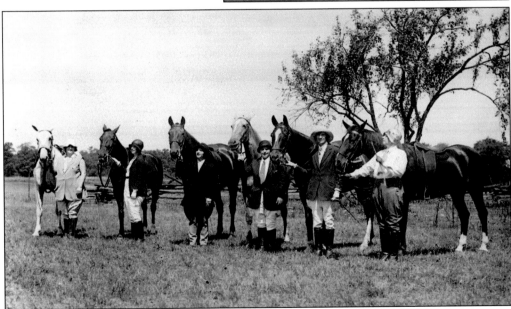

RIVER RIDGE RIDING CLUB. Northwest Columbus was served by two riding stables in what is now Upper Arlington city limits. The Duros family operated a stable near Eastcleft Road and Riverside Drive, and the River Ridge Riding Club operated out of stables north of McCoy Road. Proper attire for riding for the 1930s included breeches, clean shirts, and hats. (Courtesy of the Upper Arlington Historical Society.)

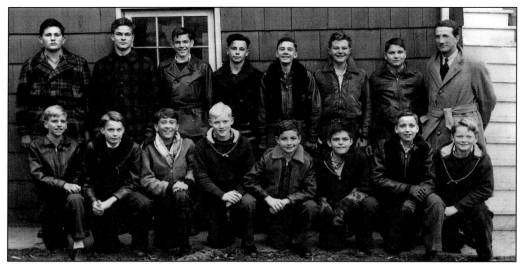

THE ASHLADS OF SIGMA RHO, 1936. The Sigma Rho Club of elementary school boys was established in 1934 around the idea of a football team and later fostered various athletic opportunities as well as field trips into the community. The club enticed Robert Boyles, a former Ohio State University athlete, to be its counselor. Included in the picture are, from left to right, (first row) Sonny Knowlton, Ted Hamilton, Bob McKay, Howdy Zeller, John Parker, Dave Putnam, Lloyd Stout, and Hobie Munsell; (second row) Dean Postle, Paul Selby, Harry Steele, Bob Mouch, Bill Kiefer, Andy Scott, John Zartman, and Boyles. (Courtesy of the Upper Arlington Education Foundation.)

CATCHING THEIR BREATH, 1940. From left to right, Jack Grey, Jinny Forsythe, Myra Smith, Dan Dupler, Jayne Weathers, and Bob Murphy take a break from the dance floor during the TAC winter dance. The event was held at the Neil House Hotel in downtown Columbus. (Courtesy of the Upper Arlington Education Foundation.)

TAC Members, 1955. Members of the TAC sorority, sporting matching attire, pose for a picture in front of 1936 Berkshire Road, which was the residence of the Dahl family at the time. From left to right are (first row) Rita Hite, Cac Cheek, Carol Dulin, Judy Grubbs, Carolyn Cook, and Jane Cellio; (second row) Sandy Blum, Jane Eaker, Jo Ann Wagner, Julie Green, Linda Thomas, Norma Zimmer, Sue Reibar, and Carolyn Reidy; (third row) Karen Woodward, Nina Griffith, Gwen Listy, Becky Bleen, Lyn Dawson, Betty Eeles, Jane Richers, and Kay Hardy. (Courtesy of the Upper Arlington Education Foundation.)

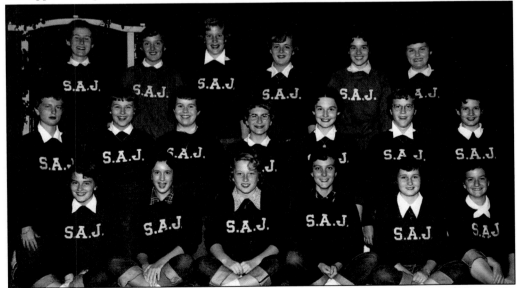

SAJ Sorority, 1953. New members of the SAJ sorority pose for a picture. From left to right are (first row) Susie Burt, Carol Fish, Doris Cooper, Mickey McSwain, Shirley Smith, and Shirley Androff; (second row) Marie Welch, Jeanne Ritter, Ginny Trott, Marty Fontana, Ann Edmondston, Janet Thomas, and Paula Morrow; (third row) Marilee Bachman, Anne Wear, Judy Wilson, Susie Schellenger, Ann Armstrong, and Judy Campbell. (Courtesy of Ann Armstrong Knodt.)

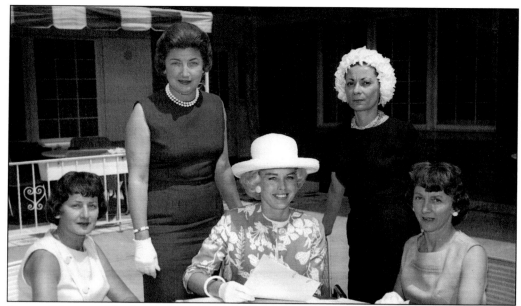

QUEEN MAKERS. Members of the Upper Arlington Civic Association's Miss Upper Arlington pageant committee gather around Chairwoman Joyce Bartell Berdelsman prior to the 1965 contest. Berdelsman was a well-known media figure in Columbus and hosted a talk show from the restaurant at the Olentangy Inn, now Cameron Mitchell's Cap City Diner. (Courtesy of the Upper Arlington Historical Society.)

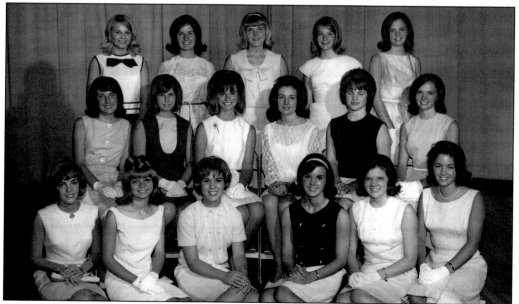

CANDIDATES FOR QUEEN. Miss Upper Arlington pageant contestants, all high school juniors and seniors from Upper Arlington, pose for this promotional image from 1965. The field presented a wide array of contestants, one of whom would reign over various events, including the upcoming Fourth of July celebration for the community. (Courtesy of the Upper Arlington Historical Society.)

CAVALCADE OF QUEENS. Miss Upper Arlington 1965, Jean Ann LeBel, is joined by her predecessors and two hopeful future queens for this picture taken in April 1966. Included in the photograph are former queens Carol Coddington (1957), Patty Albanese (1958), Susan Mueller (1960), Theresa Brown (1961), and Sally Daugherty (1964). The two young girls are Kathy Zane (holding the 1974 sign) and Missy Krieger (holding the 1978 sign). (Courtesy of the Upper Arlington Historical Society.)

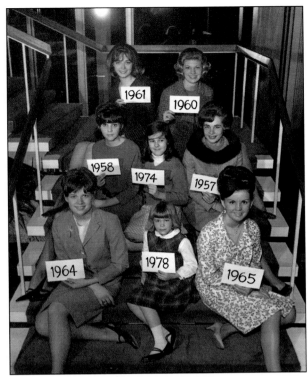

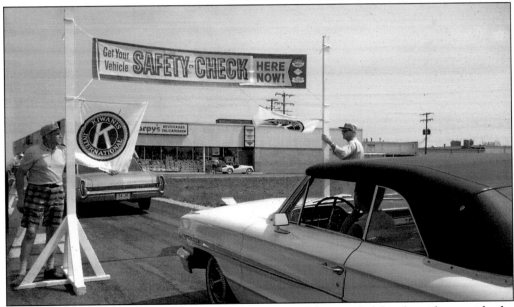

CAR CHECK AT KINGSDALE. In 1965, the Kiwanis club provided local residents with the opportunity to have their automobiles checked for safety. Drivers entered the check from Zollinger Road to have their vehicles inspected. Giant Eagle and the Kingsdale Medical Professional building now occupy the empty lot to the right in the image. (Courtesy of the Upper Arlington Historical Society.)

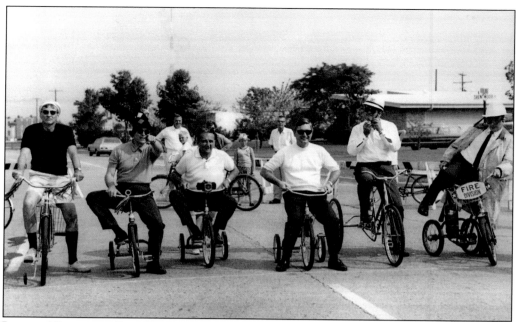

LABOR NEIGHBOR DAY BIKE RACES, 1965. Sponsored by the Upper Arlington Civic Association, the Labor Neighbor Day bike races tested skill and agility in a contest of peddle-pushing prowess. Upon reaching the finish line they most probably heard, "Dad, can I have my bike back now?" (Courtesy of the Upper Arlington Civic Association.)

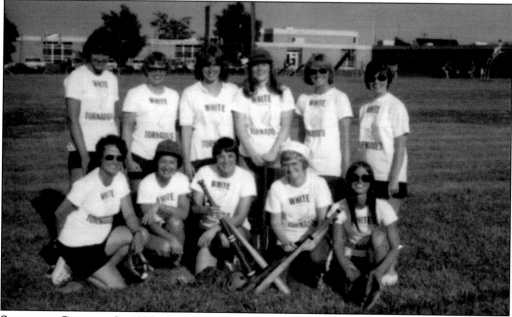

SOFTBALL CHAMPS. In 1975, the White Tornados won the city's women's softball league title. From left to right are (first row) Becky Frich, Lenore Mastracci, Nancy Busey Weese, Sandy Eckert, and Nancy Settles; (second row) Nancy Evasue, Anita Lang, Diane Cravens, Ann Gabriel, Virginia Tuttle, and Micki Ober. (Courtesy of Lenore and David Mastracci.)

Nine

FOURTH OF JULY

No other holiday celebration better defines the spirit of community in Upper Arlington than the Fourth of July. Throughout the years, the observance of the signing of the Declaration of Independence has come to symbolize both celebration of community and Upper Arlington's unofficial homecoming celebration. Rooted in the field day celebrations observed by the tri-village communities in the 1920s, Upper Arlington began its own community celebration in the mid-1920s. The festivities take months of planning and coordination by the members of the Upper Arlington Civic Association and the City of Upper Arlington.

While the celebration day begins with the largest community parade in central Ohio, other indicators show themselves days before the official kick off. Northwest Boulevard's pavement is marked with stars, and chairs begin to sprout like resurrection lilies along the parade route, marking the places from where families have traditionally viewed the parade. Floats and other entrants represent various neighborhoods and organizations. Floats can range from simple to complex. Some celebrate the day, while others provide an outlet for wit and sly observations.

Following the parade, neighborhoods and families get into the spirit by hosting block parties and cookouts. Some events are elaborate, while others are informal and relaxed. Games are played, and there is time to relax and visit before the community gathers again in the evening for the fireworks display.

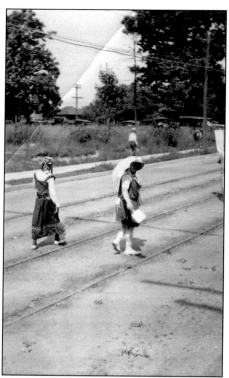

TRI-VILLAGE FIELD DAY PARADE. During the early to mid-1920s, Upper Arlington residents actively and enthusiastically participated in the annual field day celebration coordinated by the First Community Church's brotherhood organization involving the tri-village area. In 1923, Upper Arlingtonian John Wuichet dressed as a suffragette to march in the parade. (Courtesy of the Upper Arlington Historical Society.)

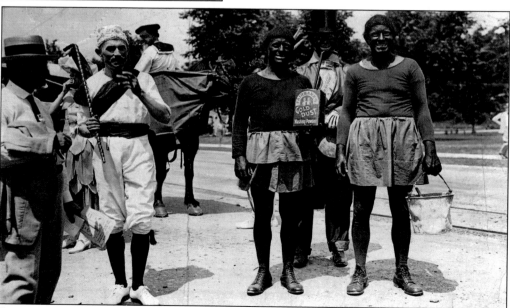

GOLD DUST TWINS, 1920s. Lacking official themes, early parades allowed participants to chose their own ideas for costumes and floats. In the 1920s, blackface and minstrel shows were still viewed as acceptable forms of humor by a great many people, the notable exception being those who were lampooned by the acts. Gold Dust was a popular soap powder of the era. (Courtesy of the Upper Arlington Historical Society.)

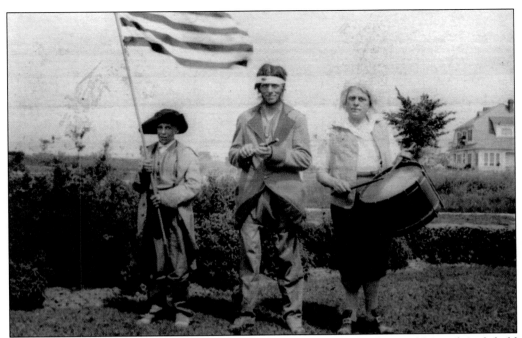

SPIRIT OF 1776. Here are the first area residents to enact the marching tableau of Archibald Willard's 1876 painting *The Spirit of '76* (originally titled *Yankee Doodle*). According to the *History of Upper Arlington* book, the reenactors, from left to right, are Ted Wells, Warren Park, and Russel Means. Also note the open land in Old Arlington behind the gentlemen. (Courtesy of the Upper Arlington Historical Society.)

FOURTH OF JULY PARADE, 1939. Friends Joyce Tefft, Sweetie Ganor, Jody Galbreath, and Rita Jeanne Brown ride in a Ford Deluxe convertible in the 1939 Fourth of July Parade. (Courtesy of the Upper Arlington Education Foundation.)

OLD WOMAN IN THE SHOE. Following World War II, neighborhoods and groups began the practice of building large floats on truck beds. This one from 1947 says. "She had so many children she didn't know what to do . . . But we do . . . Send them to Arlington!" (Courtesy of the Upper Arlington Historical Society.)

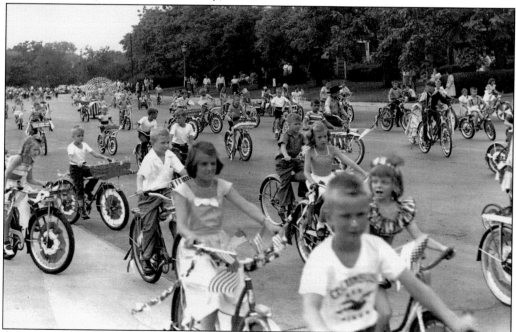

KIDS ON BIKES. Upper Arlington's youth took to the streets to show their pride in the red, white, and blue in this image from either the 1949 or the 1950 parade. (Courtesy of Linda Snashall Cummins.)

FRANKLIN AIRMAN. The Upper Arlington Company's William Yardley and George Galbraith have the seat of honor upon a bale of straw in this slide from 1951. The car, a 1928 Franklin Airman, was so named because the engine operated without water or antifreeze and was "air-cooled," an engineering feat that produced a quieter, smoother-operating automobile. (Courtesy of the Upper Arlington Historical Society.)

BABYSITTERS ON PARADE. An entrepreneurial Patti Aldin sits on the side of this entry decorated and staffed by sixth-grade students. Dressed as babies, these eager young women are clever enough to promote their babysitting business in the 1952 parade. The baby in the bonnet smoking the pipe is the father of Lynn Hammond, who provided and drove the truck. (Courtesy of Linda Snashall Cummins.)

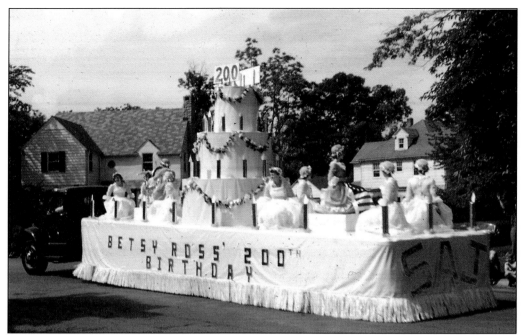

HAPPY BIRTHDAY BETSY ROSS. This float was entered into the 1952 Fourth of July Parade by the SAJ sorority. Sorority members dressed in stylized costumes to evoke the image of the woman credited with designing and making the first American flag. (Courtesy of the Upper Arlington Historical Society.)

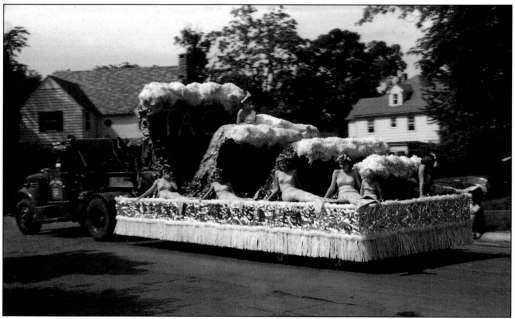

TAC WAVES. Not to be outdone by the SAJ float, the TAC sorority float took the glamour route by featuring ocean waves and mermaids for the 1952 parade. (Courtesy of the Upper Arlington Historical Society.)

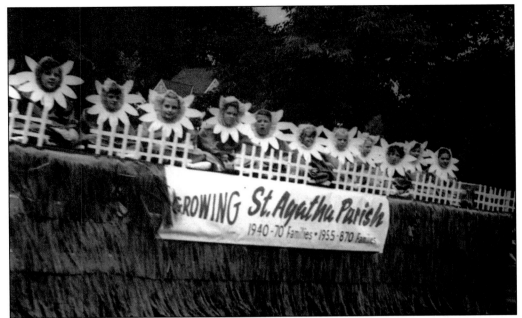

SEE THE CHILDREN GROW. In 1955, children from St. Agatha parish climbed aboard a church-sponsored float boasting that the parish (which was also the first church built in Upper Arlington) had grown from 70 families in 1940 to 870 families in 1955. (Courtesy of St. Agatha Parish.)

SPIRIT OF 1776 REDUX. In the 1963 Upper Arlington parade, the reenactors included, from left to right, Curtis "Pete" Sohl, Dr. Robert Murphy, James Millisor, and James K. Long. (Courtesy of Robert W. Wagner.)

REX LAX AND HIS GO-GO BOYS, ABOUT 1967. On July 30, 1965, Pres. Lyndon B. Johnson signed Medicare into law and opened up this opportunity to lampoon the law with "Medicare-A-Go-Go." However pointed a joke it was, the truck pulling the go-go only "went-went" about three miles per hour in the parade. (Courtesy of the Upper Arlington Historical Society.)

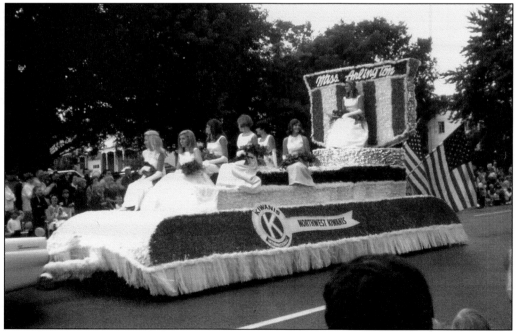

MISS ARLINGTON SALUTES UPPER ARLINGTON. For 1968, many of the floats paid tribute to the 50th anniversary of Upper Arlington's village charter. Seated atop the float was Deborah McNeil, Miss Upper Arlington for 1968. (Courtesy of Dr. Willis Hodges and family.)

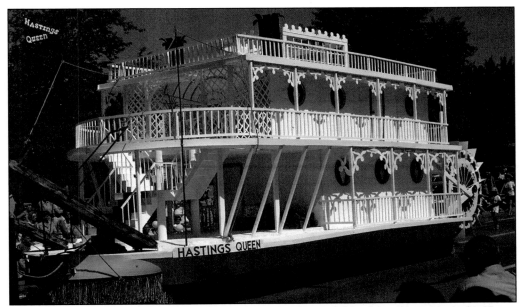

THE HASTINGS QUEEN, ABOUT 1975. The Hastings Queen was a float entered into the Upper Arlington parade by residents living on Hastings Road. The elaborate float is a classic example of the types of neighborhood entries popular in the parade at the time and a reminder of the one-upmanship practiced by the competing neighborhoods. (Courtesy of the Upper Arlington Historical Society.)

ATOP KENNY'S, ABOUT 1975. Hoping to get a better place to watch the parade, these youngsters found a way to climb atop Kenny's Gulf service center at the northwest corner of Northwest Boulevard and Zollinger Road. Of course, as parents today, they would never let their children do anything like this, would they? (Courtesy of the Upper Arlington Historical Society.)

DISCOVER THOUSANDS OF LOCAL HISTORY BOOKS FEATURING MILLIONS OF VINTAGE IMAGES

Arcadia Publishing, the leading local history publisher in the United States, is committed to making history accessible and meaningful through publishing books that celebrate and preserve the heritage of America's people and places.

Find more books like this at
www.arcadiapublishing.com

Search for your hometown history, your old stomping grounds, and even your favorite sports team.